IMAGES
of America

DURHAM
CONNECTICUT

IMAGES
of America

DURHAM
CONNECTICUT

The Durham Historical Society

ARCADIA
PUBLISHING

Copyright © 1998 by the Durham Historical Society
ISBN 978-0-7385-9008-0

Published by Arcadia Publishing
Charleston, South Carolina

Printed in the United States of America

Library of Congress Catalog Card Number: 98-87325

For all general information contact Arcadia Publishing at:
Telephone 843-853-2070
Fax 843-853-0044
E-mail sales@arcadiapublishing.com
For customer service and orders:
Toll-Free 1-888-313-2665

Visit us on the Internet at www.arcadiapublishing.com

THE DURHAM HISTORICAL SOCIETY BOOK COMMITTEE:

Katharine Newton Chase
Marilyn Keurajian
Francis E. Korn
Katharine Mauro
Roger B. Newton
Ronald Stannard

CONTENTS

ACKNOWLEDGMENTS

This book was made a reality through the longstanding passion for history and tradition in the Korn family. Francis E. Korn, currently the custodian of the archives of the Durham Historical Society, has shared his immense personal collection of photographs and historical records to make this a full and interesting book. Special thanks are due to Roger B. Newton for his amazing and colorful memory and to Kate Mauro for her cheerful assistance and editing. Credit also goes to Marilyn Keurajian for her persistence in the gathering of the committee, organizing the materials, and insisting that this book was indeed possible. Thanks to The Durham Manufacturing Company and the *Town Times* for time and space and thanks to the following people who loaned photographs to the creation of this book: Robert F. Hall, Marcia Lattime, Fred Raudat, Freda Jaycox, Henry Coe, Katharine Chase, and Ron Stannard. Thanks also to the families and employers of the book committee; we hope they will find some amount of pride in this work to equal the many hours we took from them. Thanks especially to Rachael Keurajian for the initial inspiration and support throughout.

INTRODUCTION

This pictorial history of the town of Durham is being presented in celebration of the 300th anniversary of the settling of the town. Drawn from the archives of the historical society and other private collections, these photographs show the myriad aspects of this rural New England town.

Situated between Hartford and New Haven, Durham boasts the first graduate from Yale University and, throughout the 1700s, a surprisingly high percentage of Yale graduates as residents. It should not be surprising that this area of gentleman farmers opened the very first lending library in the state, preceded nationally by only one year by the library of Benjamin Franklin. The Durham Aqueduct Company, one of the first water companies in the country, was established in 1798. During the American Revolution, Durham certainly did its part to uphold Connecticut's reputation as "the provision state." Routinely, animals and supplies were sent to support the Continental Army; Durham even sent two oxen to feed George Washington and his officers at Valley Forge. The transition from agriculture to manufacturing grew naturally from the farming, milling, and tannery days to include three thriving metal box companies, making Durham "the metal box capital of the world." Critical during the war years, metal boxes continued to be produced here, supplying both the military and commercial trade. A Durham Manufacturing first aid box was even carried to the South Pole by Admiral Byrd.

For more than 75 years, Durham has been the site of the largest agricultural fair in New England run completely by volunteers. Begun by Durham Grange #57 in 1916, The Durham Fair, once purely agricultural, has grown to include crafts, antiques, industrial & commercial displays, entertainment, and more. As many as 250,000 people visit town for this annual fall event, swelling the town's population of 6,233 to an unbelievable 40 times its regular size.

Our visit to Durham's history ends just before the start of World War II. The war years and beyond brought dramatic changes to this town, just as it did to towns and cities across our state and nation. As many can still recall today, "Life was different before the war." As the generations move on, it is our hope that this effort will preserve a little glimmer of what that "different" life was all about.

One

SPIRITUAL LIFE

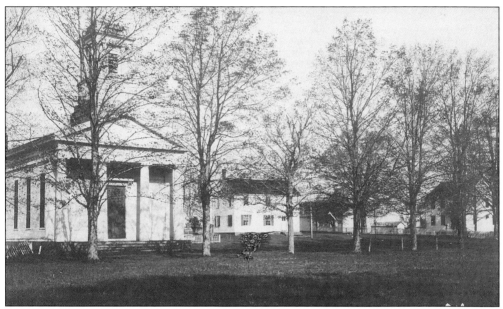

On November 17, 1709, the town voted to build the first meetinghouse upon the place commonly called the Meeting House Green. The meetinghouse was located on the crown of the hill in what is now the graveyard behind the town hall. In 1737, the first meetinghouse was replaced when a new church was built on the north end of the town green. This building remained the center of the Congregational community until 1835, when the decision was made to build a new church.

The church was built on the site of the present town hall, but it was destroyed by fire on November 28, 1844. Controversy over where the new church would be built tore the congregation apart. The situation was resolved when it was decided that two churches would be built.

The North Congregational Church, built just north of Wallingford Road, was dedicated in June 1847, while the South Congregational Church was built on the town green and dedicated in December 1849. Around 1864, a terrible gale lifted the spire of their church into the air, inverted it, and dropped it nearly perpendicularly down through the roof. In 1886, the South congregation voted to sell their building to the town for $600, and members of the North and South Congregational Churches merged.

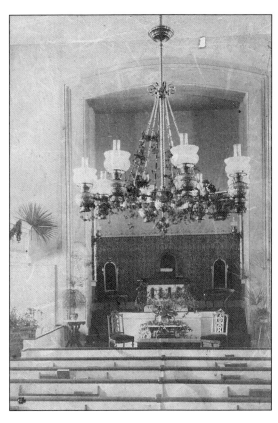

THE CONGREGATIONAL CHURCH
INTERIOR AND EXTERIOR, C. 1905.

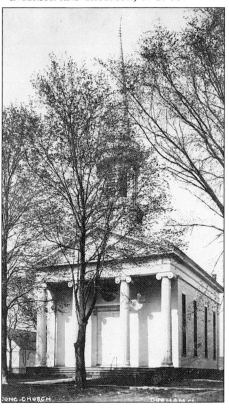

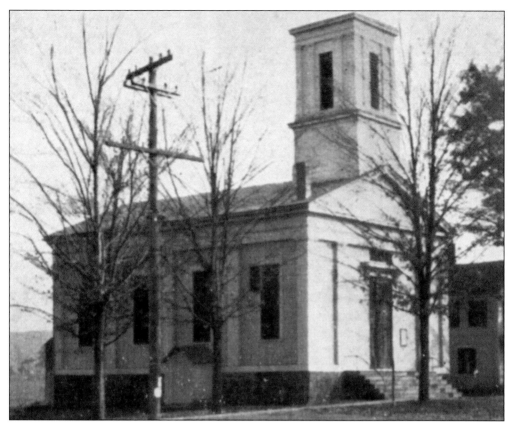

THE METHODIST EPISCOPAL CHURCH, C. 1925. The church was built on property donated by Zebulon Hale for an approximate cost of $4,000.

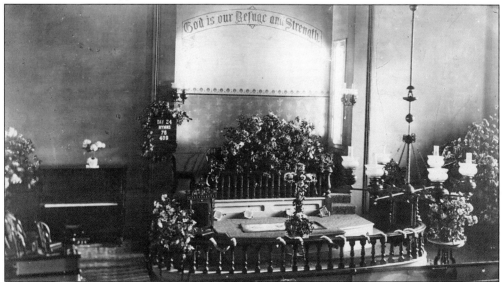

THE METHODIST EPISCOPAL CHURCH INTERIOR, C. 1905. In 1941, the Congregational Church merged with the Methodist Episcopal Church to become the United Churches of Durham. The building is currently the Durham Grange Hall.

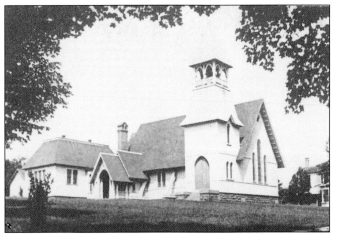

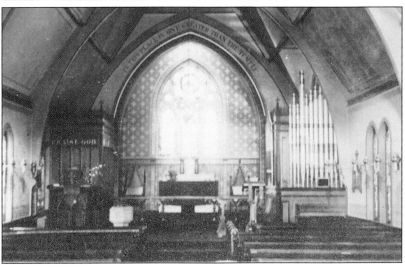

(UPPER LEFT) THE CHURCH OF THE EPIPHANY, C. 1905. The contract to build the Episcopal church was awarded on July 15, 1862. The final cost of the building and furnishing totaled $2,403.56. (MIDDLE LEFT) AN INTERIOR VIEW OF THE CHURCH OF EPIPHANY, C. 1905.

THE REVEREND MR. JOSEPH HOOPER, c. 1905. Reverend Hooper served the Church of the Epiphany from 1893 until 1916. He was also instrumental in the founding of Durham's first consolidated school, now the Frank Ward Strong School.

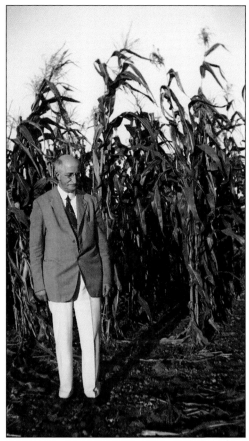

THE REVEREND MR. GEORGE B. GILBERT.
Reverend Gilbert served as the priest at the
Church of Epiphany from 1924 until 1940.
By his own choice, Mr. Gilbert was one of
the lowest-paid ministers in the Episcopal
Church; he earned a little extra cash with
his column, "The Pastoral Parson and His
Country Folks" which appeared in the *Rural
New Yorker*. Mr. Gilbert was selected by
the *Christian Herald* as "the typical country
minister" and was asked to write his memoirs.
The resulting book, *Forty Years a Country
Preacher*, received national attention when it
was published in 1939. Mr. Gilbert was also
known for his care of the less fortunate in his
parish. He established a tradition for social
responsibility throughout the county. In the
photo below, Mr. Gilbert delivers a donation
of a baby buggy.

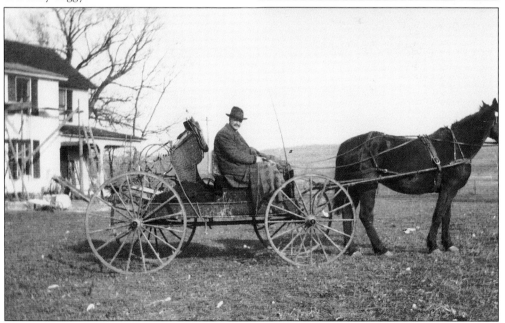

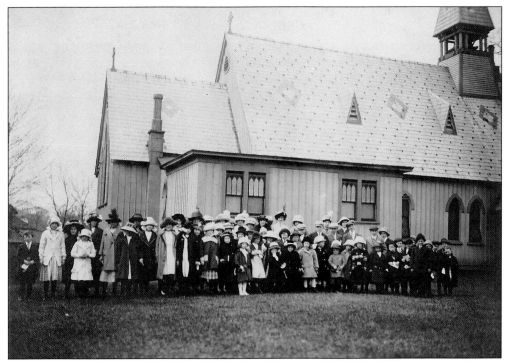

PARISHIONERS OF THE CHURCH OF EPIPHANY, c. 1915.

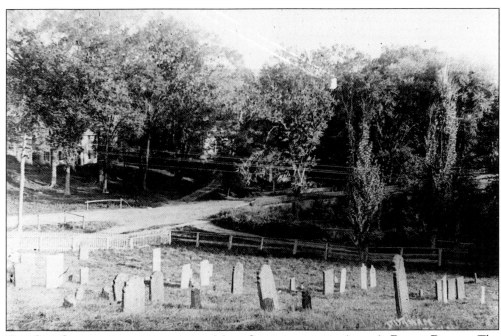

THE OLD CEMETERY LOOKING TOWARD MAIN STREET AND THE ALLYN'S BROOK BRIDGE. The land for the cemetery was donated by the original proprietors of the town of Durham. The earliest gravestone still visible is dated 1712. Durham notables Nathaniel Chauncey, Caleb Seward (the first settler), and Maj. Gen. James Wadsworth are buried here.

14

Two

RURAL SOCIETY AT PLAY

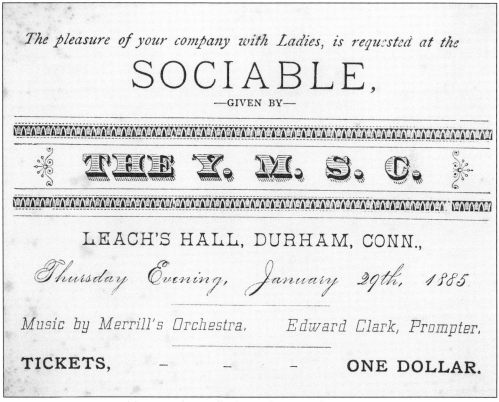

The pleasure of your company with Ladies, is requested at the

SOCIABLE,

—GIVEN BY—

THE Y. M. S. C.

LEACH'S HALL, DURHAM, CONN.,

Thursday Evening, January 29th, 1885.

Music by Merrill's Orchestra. *Edward Clark, Prompter.*

TICKETS, – – – ONE DOLLAR.

A SOCIABLE, 1885. Held in Leach's Hall, the gathering offered invited guests and ladies an evening out complete with an orchestra. Leach's Hall was on the second floor of what is now the Durham Market.

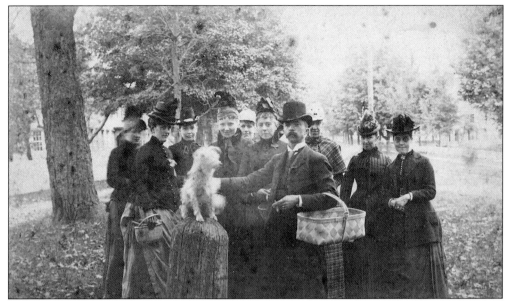

NUT GATHERING IN THE AFTERNOON, OCTOBER 11 1888. The party included Lela Severance, Helen Bonny, Lou Tibbals, Jean Crandall, Millie Mathewson, Louie Leach, Eva Warner, Alice Crandall, Anna Mathewson, and Randolph Mathewson.

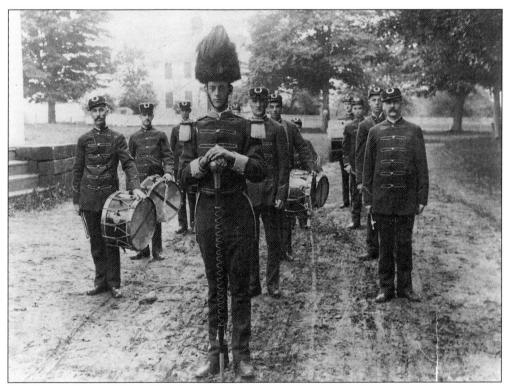

THE DRUM CORPS, 1894. This formation in front of the town hall includes Andrew Camp, Fred Newton, and John Ball. (Photographed by J.A. Fowler.)

THE OLD FASHIONED

HUSKING BEE!

——WILL BE PRESENTED BY THE——

DURHAM DRAMATIC SOCIETY,

——FOR THE——

Benefit of The Durham Public Library,

——AT——

BRAINERD'S HALL

DURHAM, CONN.,

Thursday Evening, January 31, 1895.

Cast of Characters.

UNCLE NATHAN PETERKIN, host,	W. A. PARSONS
THOMAS JEFFERSON PETERKIN, home from college,	G. H. BAILEY
SCIPIO, colored,	W. P. CAMP
JOSIAH, nervous old bachelor,	G. T. NETTLETON
ALGERNON FITZNOODLE, dude, from Boston,	F. S. JOHNSON
LITTLE LORD FAUNTLEROY, tall young man,	A. H. ROBERTS
SOLOMON LEVI, Jew pedler,	E. C. BURCKEL
AH SIN, Chinaman,	JOS. SMITH
PATRICK O'RYAN,	ELDON M. HUBBARD
BOBBY, incorrigible small boy,	HARRY RYAN
WILLIAM,	P. J. RICH
AUNT PEGGY PETERKIN, hostess,	MRS. JOS. SMITH
BETSY, fussy old maid,	MISS MARY ASMAN
KITTY MALONEY, Irish girl,	MRS. E. C. CLARK
MAGGIE,	MISS MARY FRENCH
MOLLIE,	MISS NELLIE ALLING

ADVERTISEMENT, 1895. The Durham Dramatic Society presented a benefit for the Durham Public Library on January 31, 1895. This leaflet, promising attendees "a good laugh" on a Thursday evening, was printed by E.C. Burckel, Steam Printer, in Durham.

LODGE HALL. The Knights of Pythias purchased the former Coginchaug School and used it as their lodge hall.

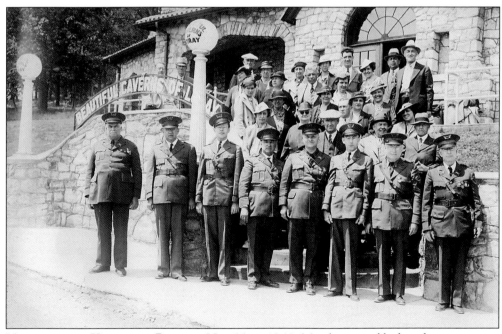

UNIFORM RANK, KNIGHTS OF PYTHIAS, NO. 66, *c.* 1940. Members stand before the entrance to the Luray Caverns during an outing to Virginia.

MARTHA ADAMEC RACHBAUER, c. 1918.
Rachbauer poses with her feisty terrier, Mutt.

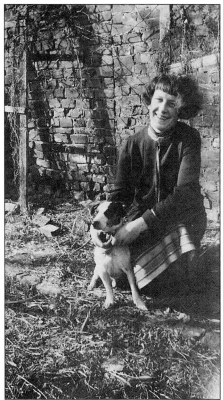

FAMILY OUTING AT SAVIN ROCK, c. 1900.
Pictured, from left to right, are the following:
(seated) Gertrude Page, Lavina Davis, Roger
Davis, and Myra Davis; (standing) unidentified,
Gertrude Hart, Rose Parsons, and Maria Davis.

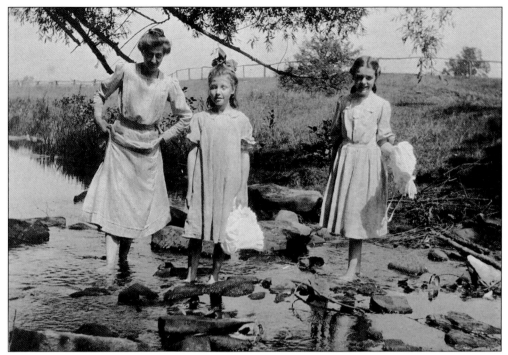

SUMMER FUN, c. 1909. The girls dip their toes in the cool water of Allyn's Brook (above) while the boys jump right in (below).

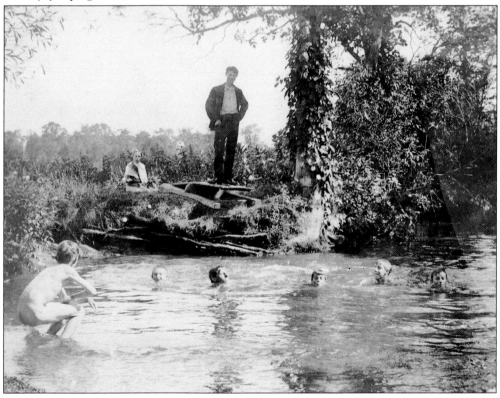

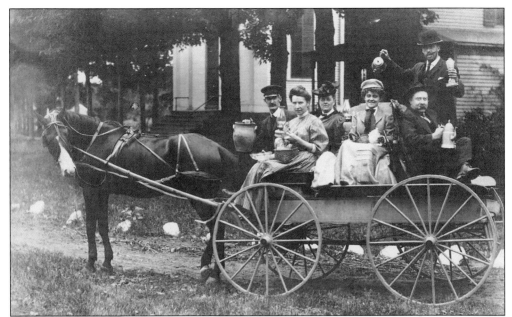

GATHERING GOODS FOR AUCTION, C. 1905. Seated, from left to right, are Walter Wilcox, Josephine Francis, Mrs. Walter (Carrie) Wilcox, Lylean Fowler Field, and Al Stone. The man in the bowler hat remains unidentified.

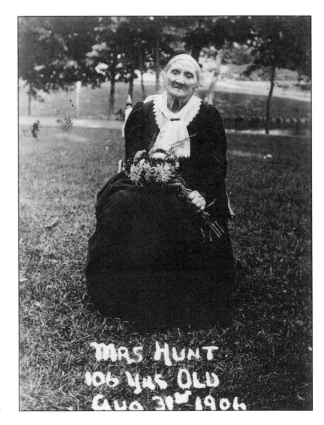

MRS. HUNT WITH FLOWERS IN 1906.

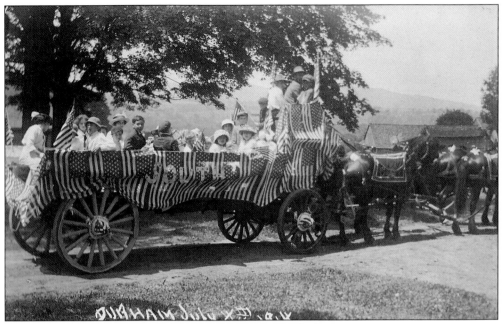

FOURTH OF JULY PARADE SCENES FROM 1907 THROUGH 1914.

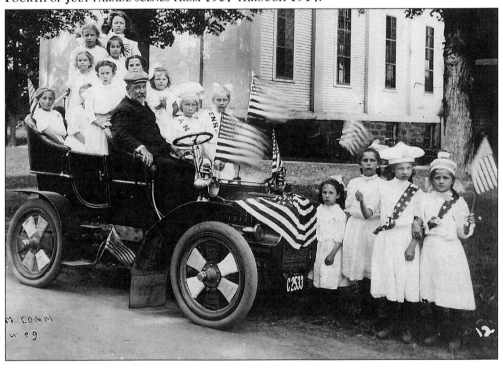

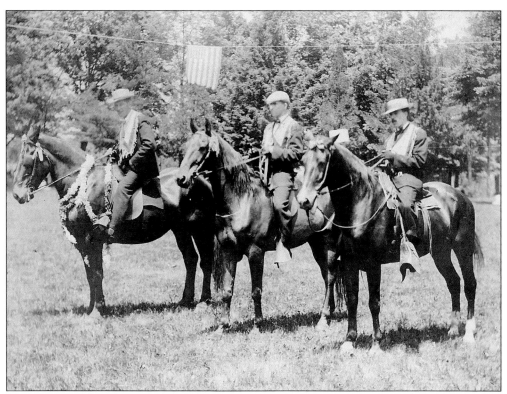

PARADE GROUPING, c. 1910. From left to right are Herbert Otte, Fred Otte, and Waldo Atwell.

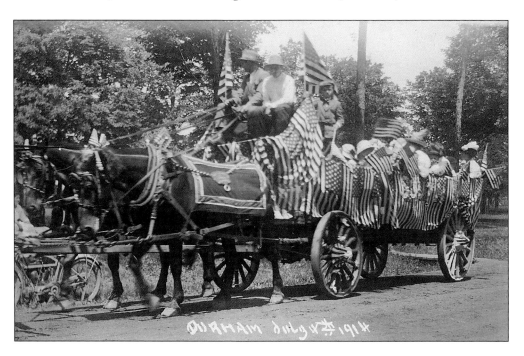

23

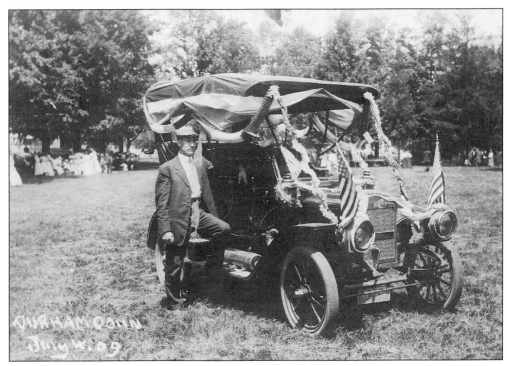

A TIME TO DRESS UP AND SHOW OFF.

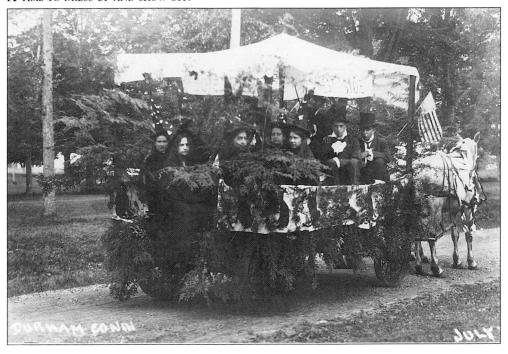

24

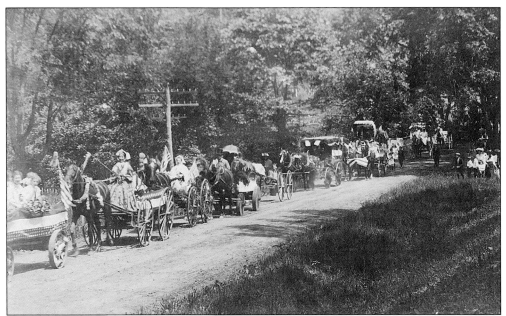

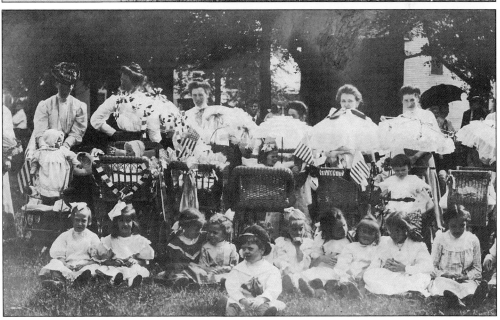

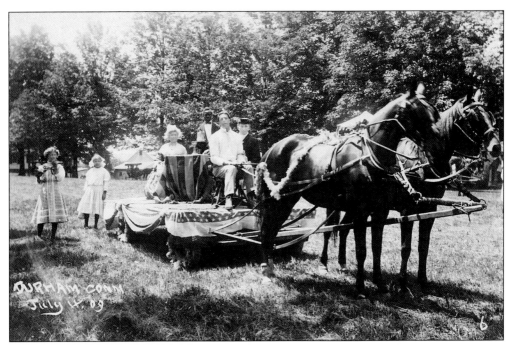

WHEELED VEHICLES OF ALL KINDS . . .

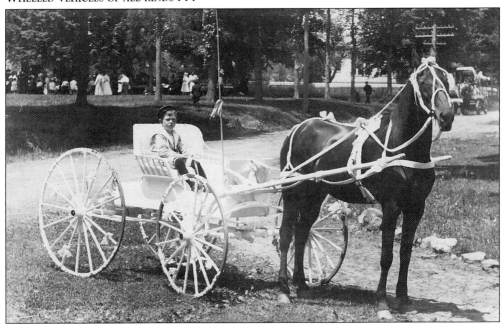

26

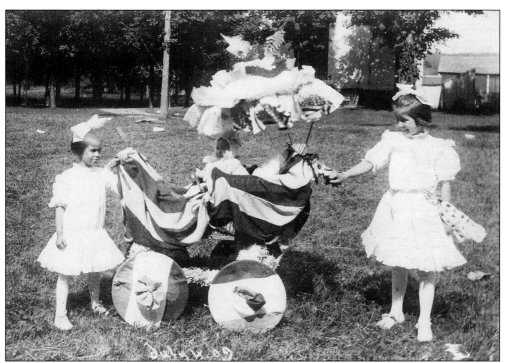

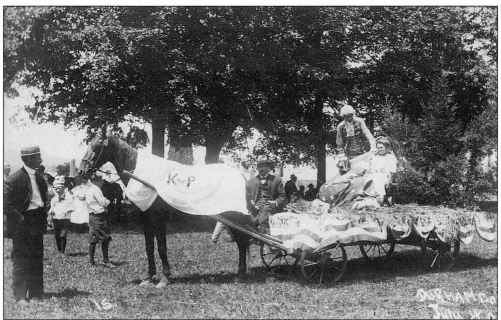

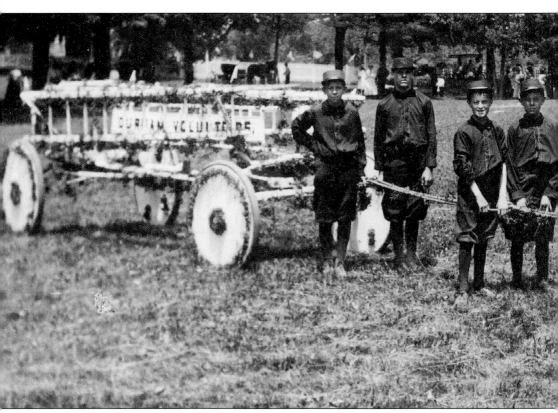

Festooned in the red, white, and blue.

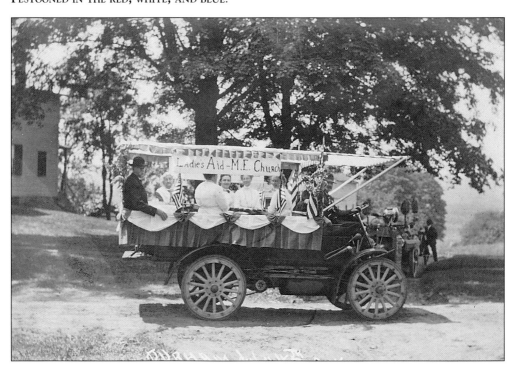

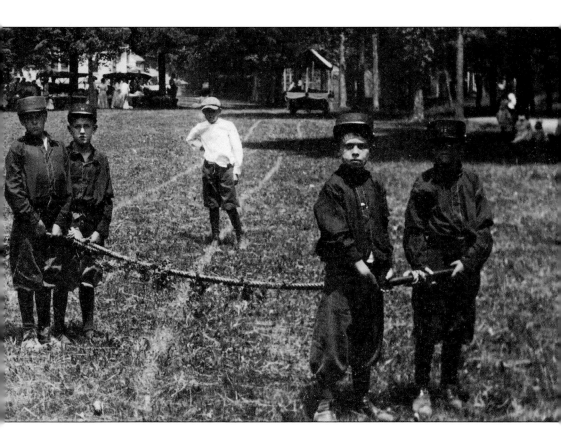

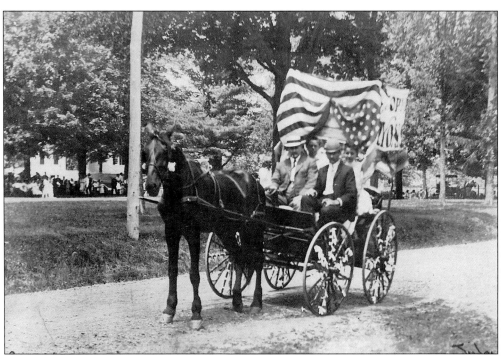

29

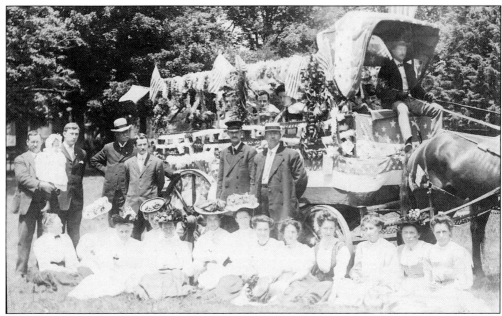

THE FOURTH OF JULY PARADE, THE MOST POPULAR EVENT HELD IN TOWN.

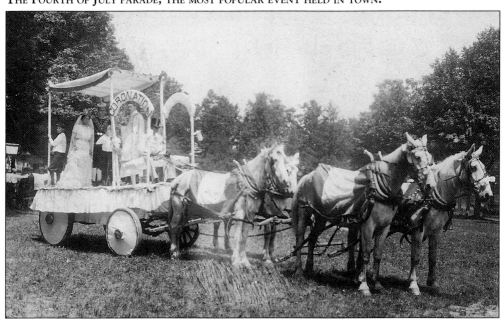

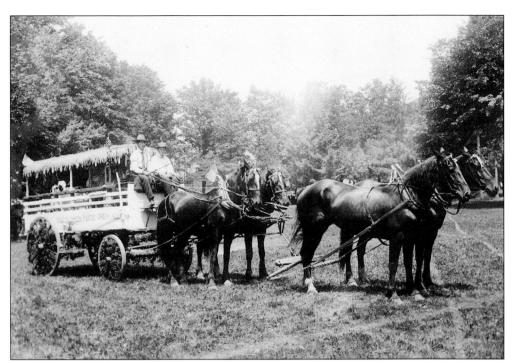

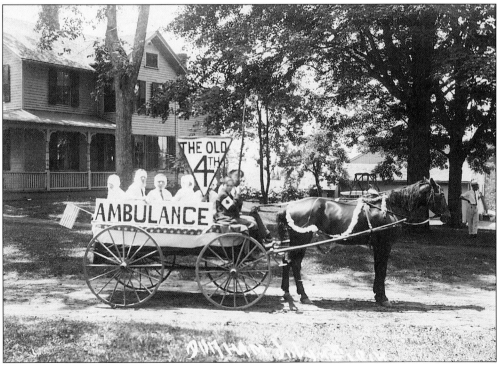

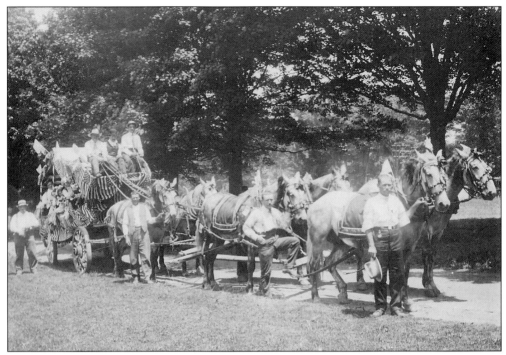

THE PARADE MARCHES ON . . .

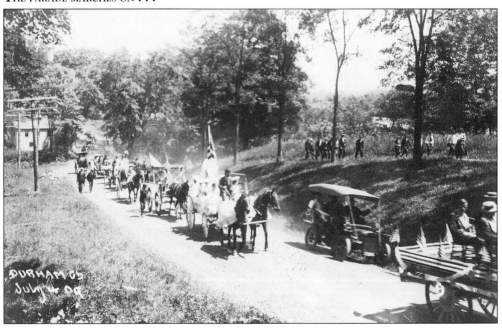

Minnie Nettleton Halleck with her husband, c. 1900. The two lived in the Sabbath Day House on Indian Lane.

A bicycle grouping, c. 1910. Pictured here, from left to right, are Helen Cooper, Hattie Cooper Calvin, Lester Calvin Daisy Burr, and Josephine Hooper.

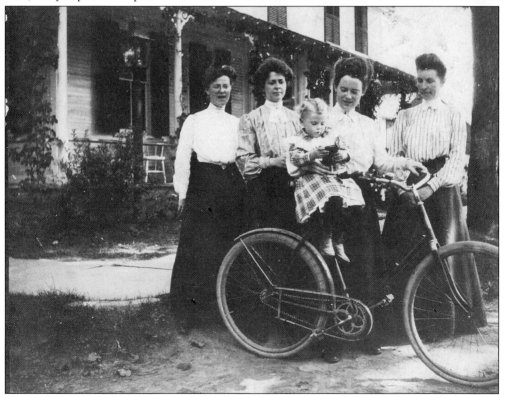

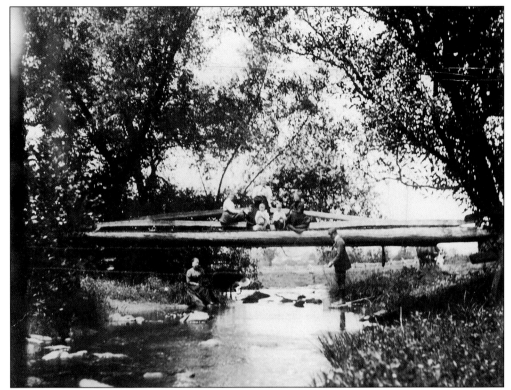

THE OLD FOOT BRIDGE ON BACK LANE, NOW MAPLE AVENUE, c. 1915. The Harvey family enjoys a summer day.

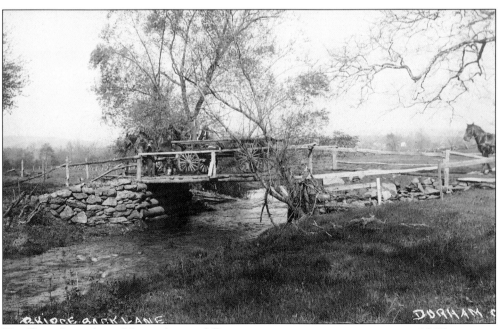

THE BACK LANE (NOW MAPLE AVENUE) BRIDGE WITH VEHICLES CROSSING IT, c. 1905.

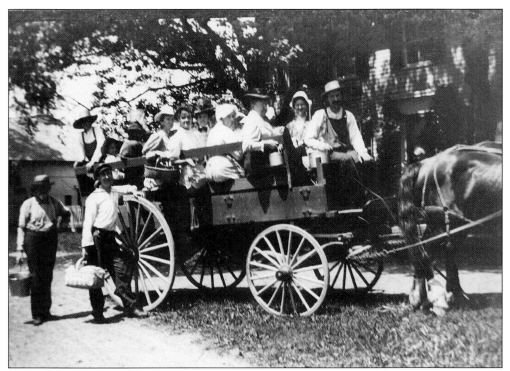

A PICNIC PARTY, c. 1905. An off-duty hay wagon and team are being put to good use by carrying a group of happy picnickers.

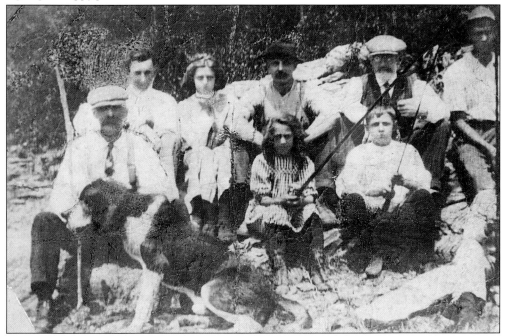

FISHING AT MILLER'S POND, c. 1910. From left to right are as follows: (front row) John Smith, Marguerite Atwell, and George Atwell; (back row) Tracy Perkins, Eunice Atwell, Fred Atwell, William Scranton, and Harold Keller.

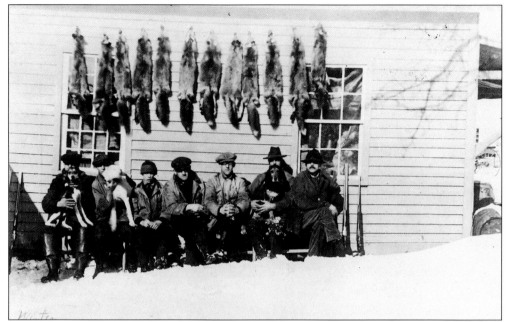

A FOX HUNTING PARTY AFTER A PARTICULARLY SUCCESSFUL DAY, 1916. Pictured, from left to right, are William Stannard, Joe Wolfe, George Atwell, Bill Gastler, Stanley Newton, Howard Atwell, and Fred Atwell.

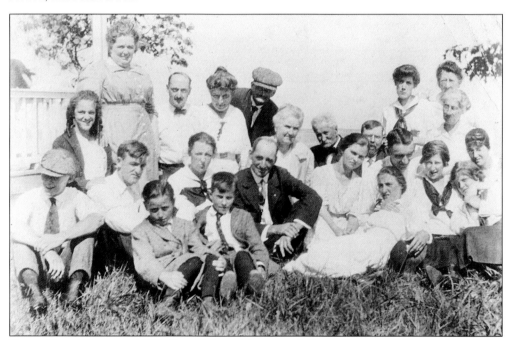

BEACH PARK MEMOIRS, 1917. From left to right are as follows: (front row) Pete Jackson, John A. Jackson; (second row) Brud Page, Warren Atwell, Dot Page, Ben Page, Deborah Jackson, Lillie Mousch, Ellis Stevens, Prudence Nettleton, Eunice Atwell, Rachel Atwell; (back row) Marguerite Atwell, Lena Atwell, Arthur Hull, Annie Page, Gilbert Nettleton, Mary Stone, Henry Davis, George Stone, Helen Ennis, Louise Nettleton, and Mary Asman.

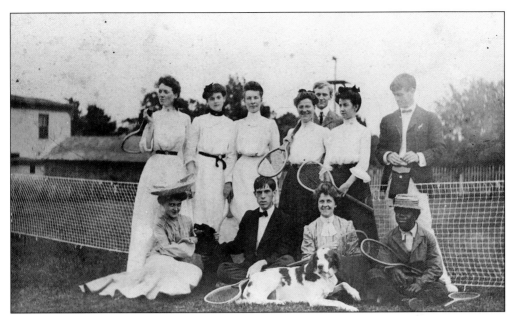

THE TENNIS CLUB, c. 1910. From left to right are as follows: (standing) Maude Markham, Hilda Alling, Josephine Hooper, Helen Cooper, Lester Markham, May Meigs, Leonard Markham; (seated) Jeannette Schmidt, Jessie Rich, Hattie Cooper, and John Jefferson Jackson.

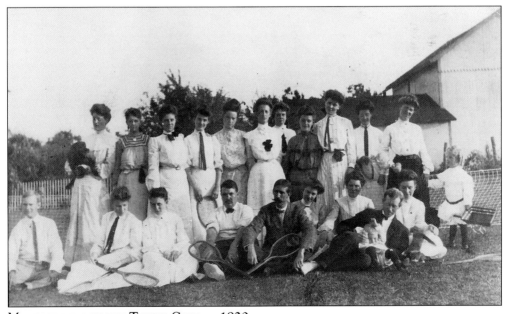

MORE MEMBERS OF THE TENNIS CLUB, c. 1920.

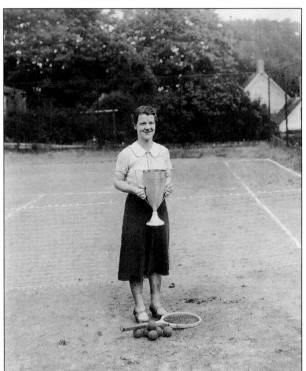

MARION HARVEY, c. 1930.
Winner of an impressive
trophy for tennis, Marion was a
memorable teacher for many.

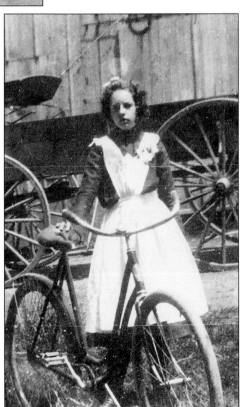

**MILDRED ATWELL AND HER BICYCLE,
c. 1930.** Mildred, or Dot as she was known,
was also a local teacher.

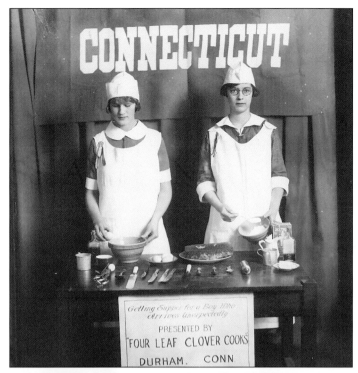

Four Leaf Clover cooks, c. 1930. Margaret David and Evelyn Cornall demonstrate "Getting Supper for a Boy who Arrives Unexpectedly."

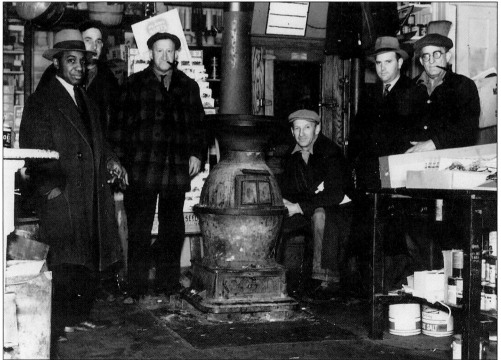

Around the stove at Ackerman's Store, 1938. Pictured, from left to right, are John Jefferson Jackson, William Zeiroth, Jim Scott, William Gastler, John Jackson, and Clifford Thompson. (Photographed by Officer D. Mielke.)

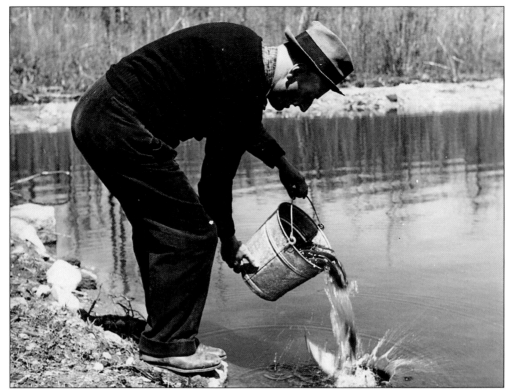

FRED RACHBAUER, STOCKING THE FAMILY POND WITH TROUT, 1939. In the business of water, Rachbauer Brothers drilled artesian wells throughout New England.

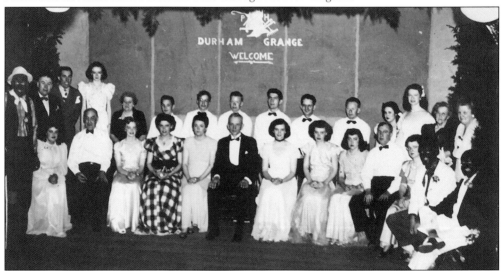

GRANGE MINSTREL SHOW, c. 1945. The individuals pictured here are, from left to right, as follows: (front row) Al Hanson, Mary Kline, Dave Powers, Vera Pratt, Patty Powers, Doris Martin, "Interlockter" Henry Berten, Helen Korn, Janet Berten, Jeannette Loveland, Frank Korn, Marion Harvey, and two unknown men; (back row) Eddie Kosicki, Frank Covney, Harriet Stevens, Gladys Otte, Buddy Chapman, John Henry Gastler, Forrest "Joe" Hall, Lee Arcand, Lloyd Sweet, Bob Hall, Rose Mary Sweet, unknown, Bernice Berten, and Dot Hanson.

Three

BUSINESS AND INDUSTRY

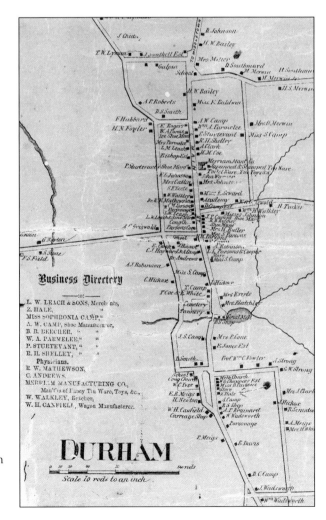

A MAP OF DURHAM'S BUSINESS DISTRICT, c. 1859, DEPICTING A NORTH-SOUTH VIEW OF MAIN STREET. Notable businesses featured include Merriam Manufacturing, the L.W. Leach & Sons Store (now the Durham Market), the tannery, and Durham Academy. There were quite a few in-home businesses for the manufacture of shoes.

THE SWATHEL TAVERN, c. 1905. In 1794, John Swathel Jr. bought a quarter interest in the stage line between Springfield, MA, and New Haven, CT. In 1802, he purchased the Abiel Coe Tavern, an establishment along the stage route, and renamed it the Swathel Tavern. The tavern became the most prosperous in town, due in large part to the four daily stops by the stagecoach line. It was formerly located on the north corner of Middlefield Road (Route 147) and Main Street.

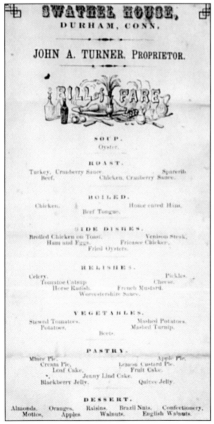

A SWATHEL HOUSE BILL OF FARE, 1867. The offerings are varied and tempting.

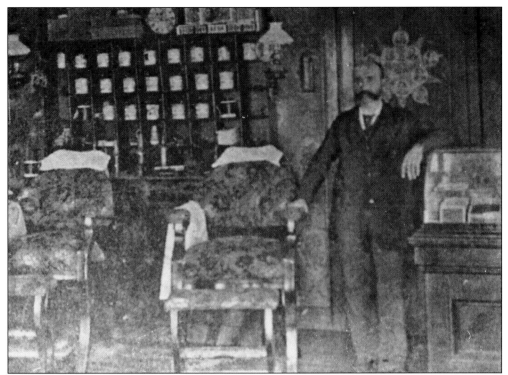

BURCKEL'S BARBER SHOP AT THE SWATHEL INN, c. 1900. There were two chairs located here and no waiting. Notice the personal shaving mugs of regular patrons on the back wall.

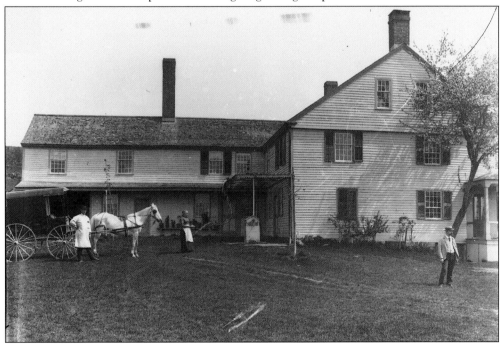

A REAR VIEW OF THE SWATHEL HOUSE SHOWING A DELIVERY WAGON, HOTEL PERSONNEL, AND A DAPPER GUEST.

THE TANNERY, c. 1905, LOOKING NORTH ON MAIN STREET. The tannery was located on the west side of Main Street near the bridge over Allyn's Brook. It supplied leather to the thriving shoe industry in Durham. Often shoes were sent by wagon to Middletown and then loaded on ships bound for ports in the southern states.

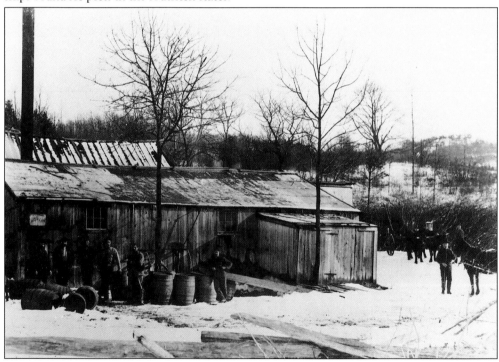

THE BIRCH MILL, LOCATED ON BIRCH MILL ROAD NEAR THE SITE OF THE PRESENT TIME OUT TAVERNE. Between 1882 and 1904, the mill distilled witch hazel for the E.E. Dickinson Company of Essex. As the witch hazel bushes began to disappear, the mill produced birch and, later, wintergreen extracts.

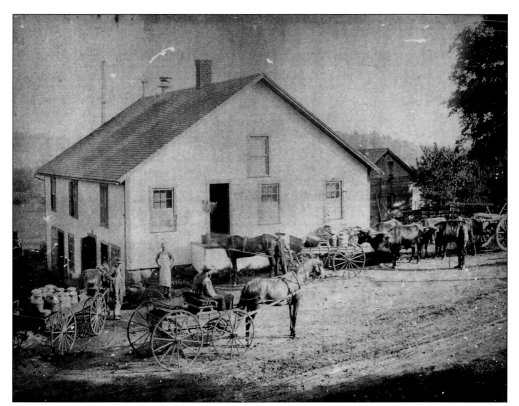

THE DURHAM CREAMERY, INCORPORATED ON JUNE 25, 1874, ON NEW HAVEN ROAD. Farmers would bring milk to the creamery, where the cream would be separated from the milk to be made into butter. The creamery closed on November 1, 1906.

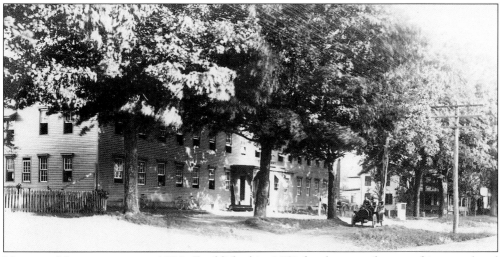

MERRIAM MANUFACTURING, 1908. Established in 1851 for the manufacture of japanned and stamped tinware, Merriam's early reputation was built on tin toys. Located on Main Street, the original structure was consumed by fire in 1918. It was rebuilt and the business is still in operation today.

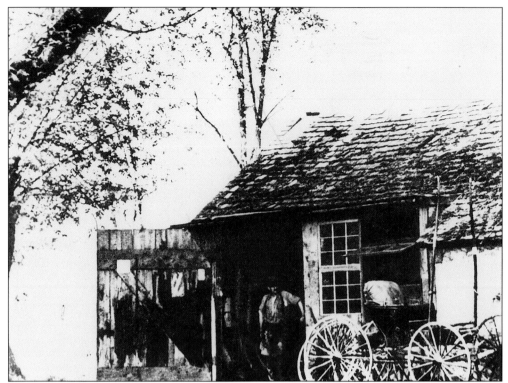

JOHN STEVENS BLACKSMITH SHOP, c. 1900. The Stevens forge, located on Howd Road, was one of several blacksmith's shops located in Durham.

EVERETT EDWARD CARLSON, c. 1910. Owner of a blacksmith shop south of Pickett Lane, Carlson married Myra Goodale, who lived at the Goodale House near the old cemetery.

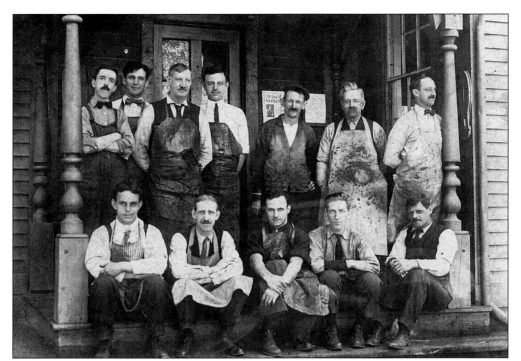

POSING ON THE FRONT STEPS AT MERRIAM MANUFACTURING, c. 1905. From left to right are as follows: (standing) Waldo Atwell, Will Murray, Ed White, Oscar Wimler, Gus Kerner, Elmer Stevens, Arthur Hull; (seated) Geoge Bank, Ed Francis, Gustave deMacarty, John Otte, and Adolph Bode.

DURHAM, CONN., 3/10 1902 189

MERRIAM MFG. CO.'S SCALES.

THIS CERTIFIES, That I have weighed a load of *Hay*

brought by *Robt Davis*

For

owned by *Geo H. Davis* *Peete*

Whole Weight, - - -	2650	lbs.
Weight of Wagon, - -	1200	lbs.
Weight of *Hay*	1450	lbs.

Weigher.

A HAY RECEIPT, 1902. The Merriam scale was used by many freight haulers and local residents for weighing their wagonloads.

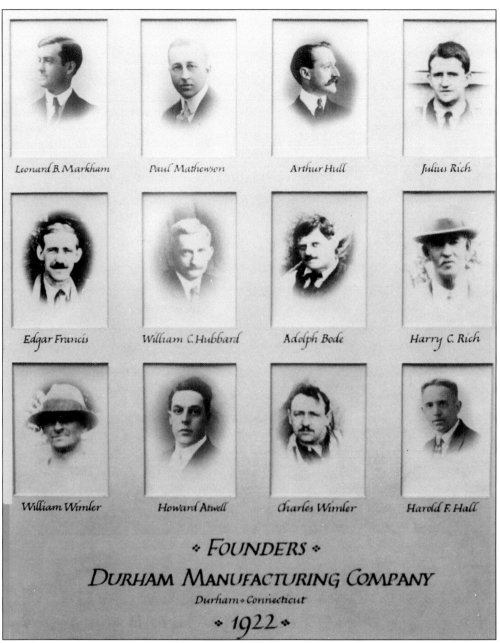

Leonard B. Markham

Paul Mathewson

Arthur Hull

Julius Rich

Edgar Francis

William C. Hubbard

Adolph Bode

Harry C. Rich

William Wimler

Howard Atwell

Charles Wimler

Harold F. Hall

❖ FOUNDERS ❖

DURHAM MANUFACTURING COMPANY

Durham ❖ Connecticut

❖ 1922 ❖

THE DURHAM MANUFACTURING COMPANY. In 1922, these 12 men, some former employees of Merriam Manufacturing, formed the Durham Manufacturing Company. The company manufactures metal storage bins and cabinets, first aid boxes, and metal office products for customers worldwide.

FRANK KORN, PRESIDENT OF THE DURHAM
MANUFACTURING COMPANY, LENDING A HAND IN
THE CONTINUED GROWTH OF THE FACTORY.

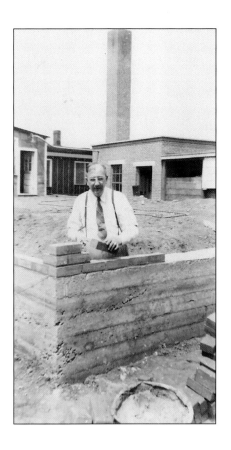

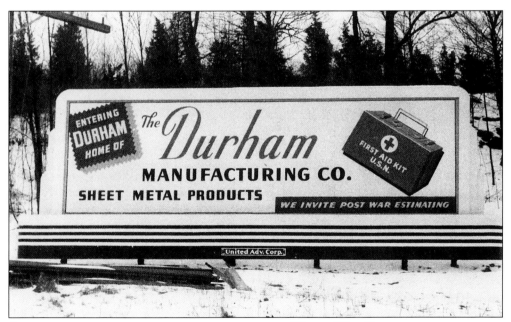

A BILLBOARD LOCATED AT THE EDGE OF TOWN DURING WORLD WAR II.

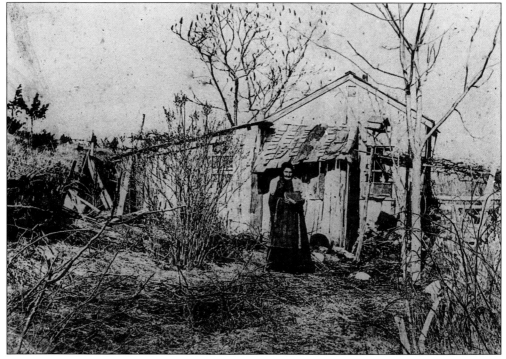

THE HOME AND BUSINESS OF ESTHER BEAUMONT, c. 1890. The last Native American resident of Durham, Beaumont made baskets at her home on Indian Lane and walked to Middletown to sell them. She died in 1893 at the age of 86.

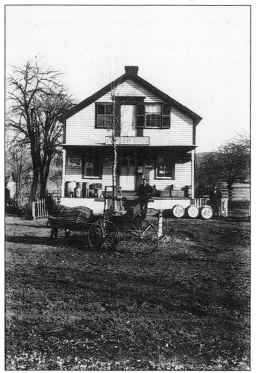

THE FOWLER BROTHERS STORE, c. 1895. Originally owned by Zebulon Hale, the store was purchased in 1861 by George Davis. George Davis operated the store with F.J. Coe under the name Davis & Coe until 1863. In 1870, George Davis sold the store to the Alling Brothers, but George and Henry Davis bought the store back from the Allings in 1872. They operated it until 1875 as Henry Davis & Co. In 1883, the store was acquired by the Fowler Brothers. The building is now the residence of William and Jacqueline Nelson and family.

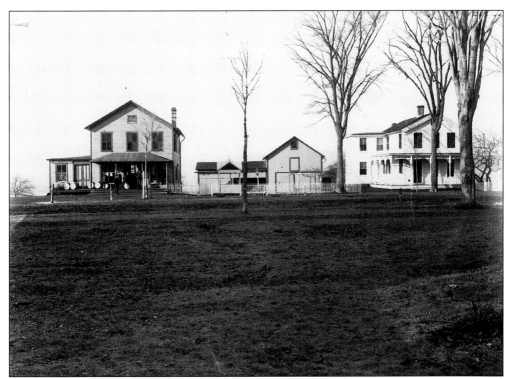

THE HENRY DAVIS STORE, c. 1900. Henry Davis built this store in 1878 and carried a full line of groceries, hardware, farming implements, grain, and feed. The store also served as the post office. It later became the A.M. Ackerman Store.

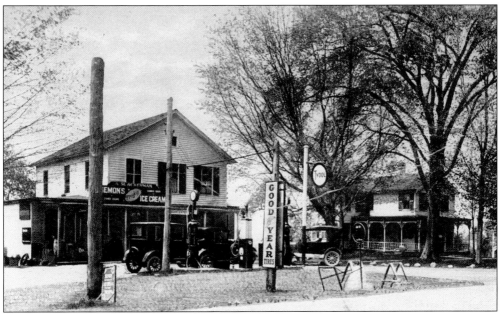

THE A.M. ACKERMAN STORE, c. 1920. A sign advertises lemons, ice cream, gasoline, and tires, a variety indicative of the wide range of goods available in this general store. This tradition lives on as Ackerman's continues to carry a surprising variety of goods.

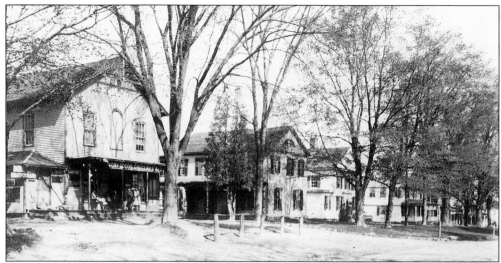

THE ATWELL BROS. STORE, C. 1905. In the below photo, from left to right, are Joe Scovill, Maurice Hull, Stanley Newton, Earl Mathewson, Jesse Atwell, Myron Atwell, Paul Mathewson, George Atwell, Fred Atwell (in buggy); left to right on porch are Harry Hurd and Cleman Burr. This retail store, located just north of the United Churches of Durham, was founded by Leverett W. Leach in 1835. In 1843, L.W. Leach's oldest son, Leverett M. Leach, joined his father's business, and it became known as L.W. Leach and Son. In 1855, a second son, Oscar, became a partner, and the store was known as L.W. Leach & Sons. After their father's death, the Leaches continued to run the store as L.M. & O. Leach. In 1889, the store was sold to F.L. Wellman and F.S. Newton. Their tenure at this location ended when they sold the store to Fred L. & Jesse B. Atwell in 1897. The Atwells's store prospered, boasting a post office and a general reputation as a "good business." The Otte family purchased the store and operated it as Morse & Otte's until 1994, when it was sold to Mounts and Sons L.L.C. It is now run by Chet, Jackie, Bob, and Jason Mounts as the Durham Market.

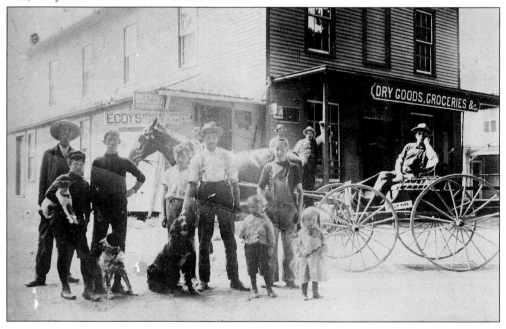

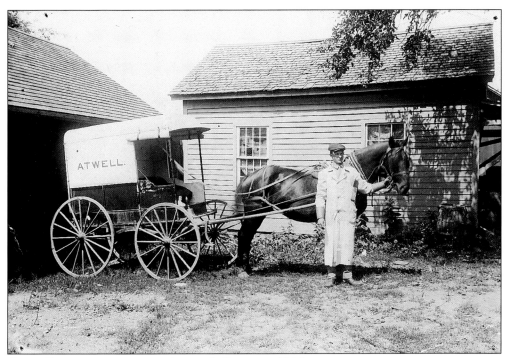

TRACY PERKINS, A DRIVER FOR ATWELL'S STORE, c. 1900.

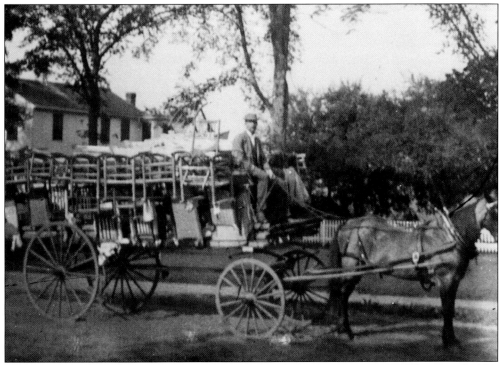

JACOB ZEISSETT OF FOWLER AVENUE, c. 1900. Zeissett began his career as a peddler around 1890, selling ladders, chairs, and baskets from his wagon throughout Connecticut and Westchester County, New York.

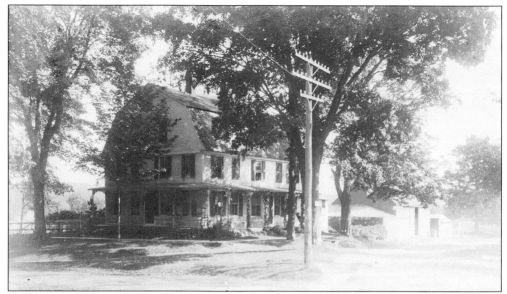

NEWTON'S HOTEL, c. 1900. From the end of the Civil War until the early part of this century, Durham was a popular resort town, especially for residents of New York City. The urban dwellers came to Durham in search of a quiet, tranquil place in which to rest and relax. Durham homeowners catered to this demand, inviting tourists into their homes as boarders. This hotel, located on the corner of Main Street and Maiden Lane, was owned by Fred Newton. It later became known as the Allen House. This is now the home and business location of the Russell Quick family.

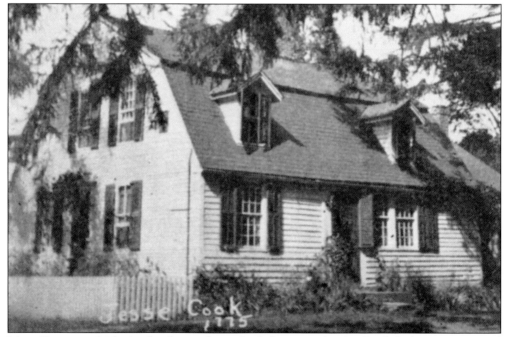

MILL HILL, c. 1915. At the former Jesse Cook homestead, Mrs. Ruth Roberts Mix served "country meals . . .by reservation." This is currently the home of Marcia Lattime, who was a friend of Mrs. Mix.

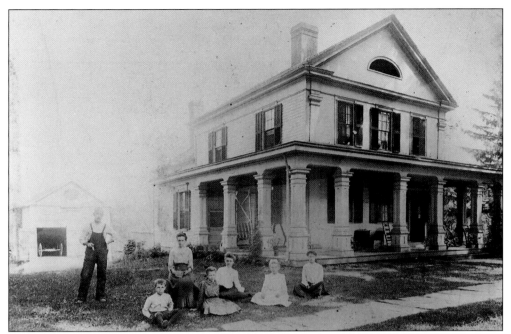

AUNT HEDDY'S PLACE. Located opposite Wallingford Road on Main Street, this house is now owned by Dick and Daniel Kellish. Pictured here, from left to right, are John Smith, Roy Smith, Heddy Smith, Agnes Smith, and three boarders.

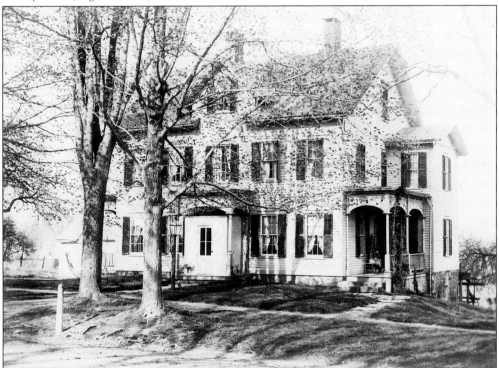

THE HUBBARD HOUSE, 1920. This guest house, located at the junction of the Wallingford Road and Main Street, was a popular one. It is now the home of Dr. and Mrs. Francis E. Korn.

POSTCARDS, c. 1920. These popular, if fanciful, vacation scenes of Durham were sold at local stores. Mass produced out of town, the cards were stamped "Durham" even though they often had very little to do with actual town life.

ANOTHER C. 1920 POSTCARD VIEW. This scenic lake view invites Durham visitors to a lake that doesn't even exist in Durham.

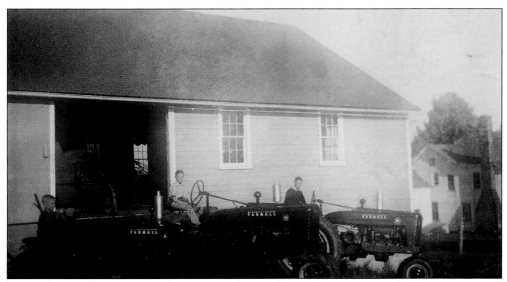

CLEVE STANNARD'S TRACTOR SHOP, 1938. Selling International Harvest Farmall Tractors and New Idea Equipment was a natural progression for this Durham farmer after tractors replaced horses and oxen.

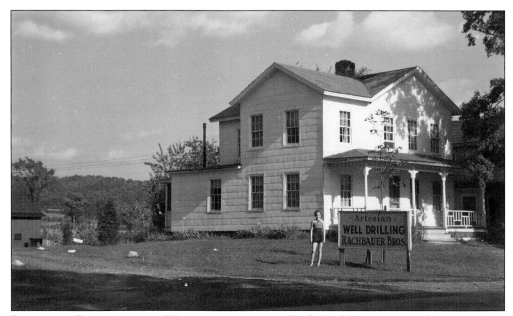

RACHBAUER BROS. ARTESIAN WELL DRILLING, 1939. Freda Rachbauer poses at the sign in front of the business on Main Street, at one time the largest artesian well drilling company in New England. The residence was built in 1852 by Henry Williams; in 1854, Alanson Brainard added a building in the back which was operated as a general store for many years. Now the home of Freda (Rachbauer) Jaycox's daughter, Marilyn Keurajian, her husband, Paul, and their family.

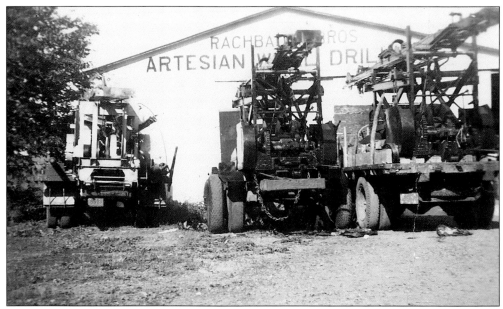

ARTESIAN WELL DRILLING RIGS, c. 1939. The rigs are seen here looming in front of the shop where Rat's Bicycle Shop operates at 63 Main Street.

Four

EDUCATION

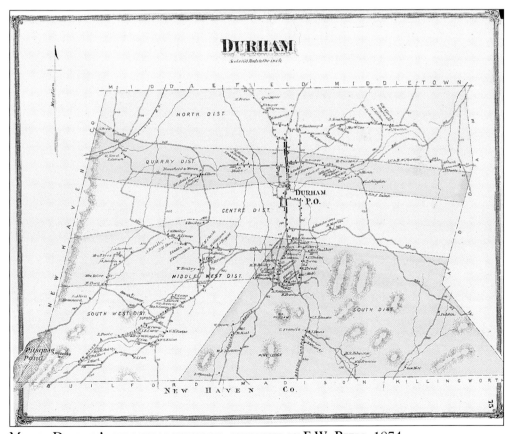

MAP OF DURHAM'S SIX SCHOOL DISTRICTS, PUBLISHED BY F.W. BEERS, 1874.

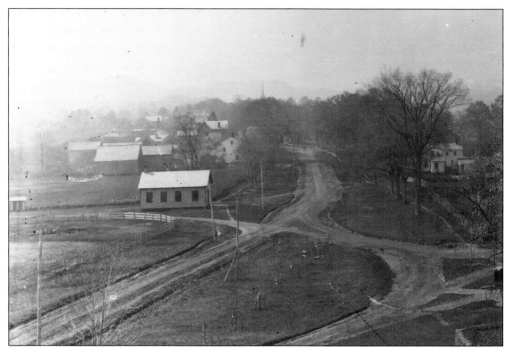

THE NORTH DISTRICT SCHOOL, c. 1895. The school was located at the intersection of Haddam Quarter Road and Main Street. It is the present location of the A & A Package Store.

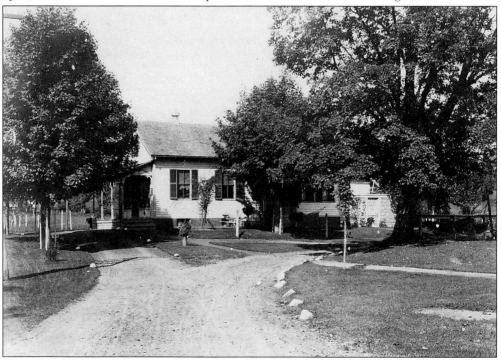

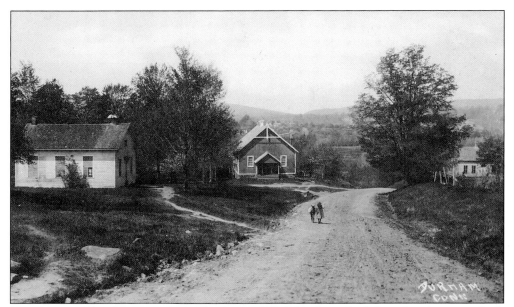

THE QUARRY HILL SCHOOL, 1905. The Quarry Hill School, on the left in this photo, was built in 1834 on the southeast corner of Maple Avenue and Wallingford Road. In 1856, teacher Julia Catlin was paid $4 per week for her services.

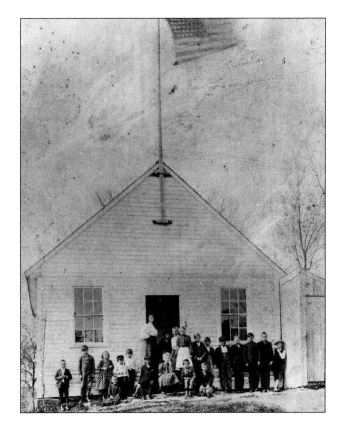

THE SOUTH DISTRICT SCHOOL, 1910. Built on Sand Hill Road in 1802, this school was in use until 1923. It is currently a private residence.

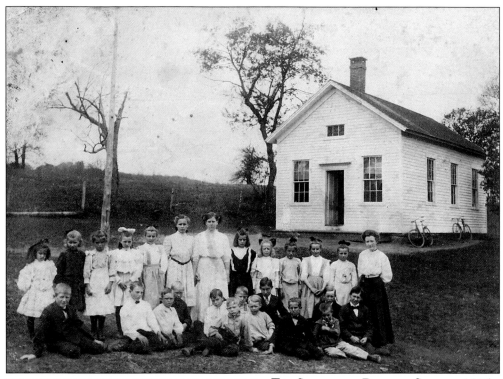

THE SOUTHWEST DISTRICT SCHOOL, 1905.
The school was built in 1834 on the
southwest corner of the New Haven Road
and Howd Road. It is presently the home of
the Bernacki family.

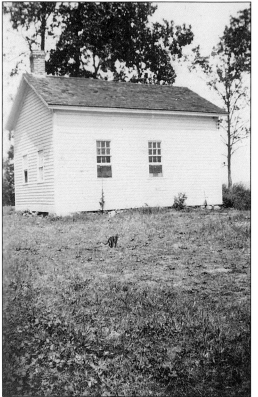

THE WEST SIDE SCHOOL, 1905. Built
in 1834 on the north side of the summit
of Parmelee Hill Road, this building
was moved to Wilbur's Lane in North
Guilford and has been restored as a
schoolhouse by its present owner.

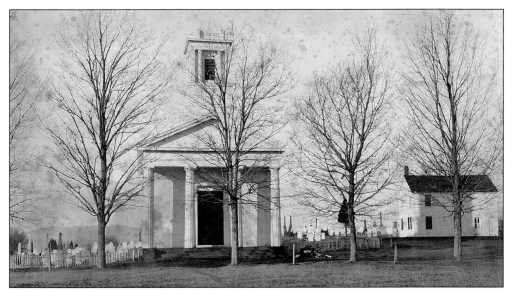

THE CENTER SCHOOL, 1905. The Center School or the Academy on the Green (pictured on the right) sits on property donated by Ebenezer Robinson. It is now the headquarters of the Durham Historical Society.

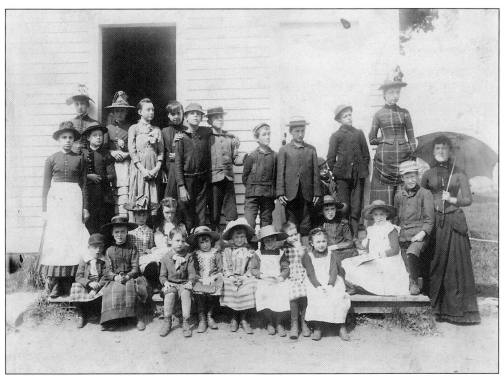

A CENTER SCHOOL CLASS PICTURE, 1886. Pictured, are Nellie Alling, Grace Meigs, Jennie Tryon, Leonard Markham, Will Stannard, Jesse Atwell, Anne Fowler, Lena Sage, May Meigs, Maude Markham, Ruth Fowler, Oliver Markham, Miss Mary Munger (teacher), Waldo Atwell, Robert Meigs, Gertrude Parsons, Gertrude Fowler, and Lylean Fowler.

DURHAM ACADEMY.
TERMS.

Tuition in the common English per term of *eleven* weeks, - - - - - - $4.00

Book-keeping, Chemistry, Philosophy, the higher Mathematics, the Greek and Latin Languages, 5.00

Pupils under nine years, from - - - - - - - $2.50 to $3.00

A small extra charge for Incidental expenses.

N. B.— Every bill must be paid on or before the *last day* of the term.

Durham, *July 24,"* 1843.

Mr. *J. Hall*

To J. D. POST, Dr.

To Tuition for *one* pupil *one* term at $ *4.* - - - - - - $ *4.00*

" Stationery, Books, - - - - - - - -

" Damage, - - - - - - - - - -

Term ending *July 29"* 1843.

Received Payment, *John S Post* $ *4.00*

A DURHAM ACADEMY TUITION RECEIPT, 1843. One 11-week term cost $4 at this private school, which promised an education in "common English." Note also that the term ended on July 29.

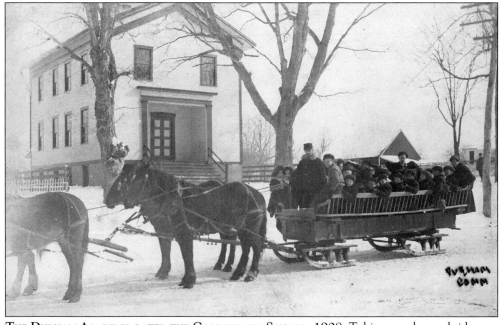

THE DURHAM ACADEMY, LATER THE COGINCHAUG SCHOOL, 1908. Taking a welcomed ride on a snowy day, these children are bundled up and pictured in front of the school. This is the current location of Nationwide Insurance.

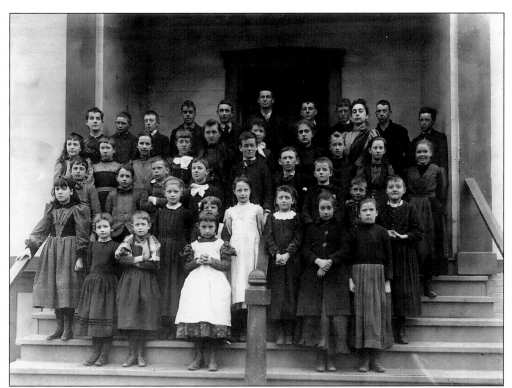

THE COGINCHAUG SCHOOL, 1900. Among the students posing for this class picture are H.P. Ryan, William Fowler, R. Bailey, Harry Rich, Sheldon Harvey, Chris Tucker, Daisy Rich, Hattie C. Newton, May Meigs, Grace Fowler, Robert Meigs, Leonard B. Markham, John Synot, Junie Rich, Ruth Tucker, Emma Brown, and Grace Meigs.

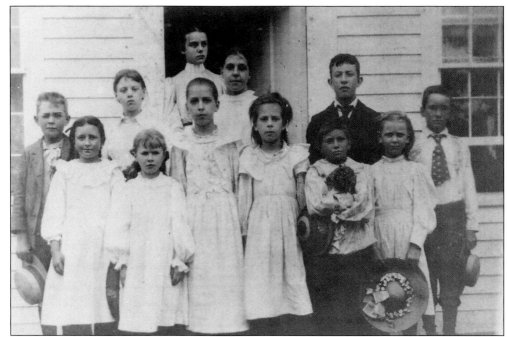

THE WEST SIDE SCHOOL, 1900. From left to right are as follows: (front row) Isabel Clark, Luva Austin, Lilla Eick, Bertha Eick, Charlton Clark, Myra Davis, and Elmer Clark; (back row) Roger Davis, Mary Cunningham, Miss Maude Cole (teacher), Elsie Eick, and Clifford Clark.

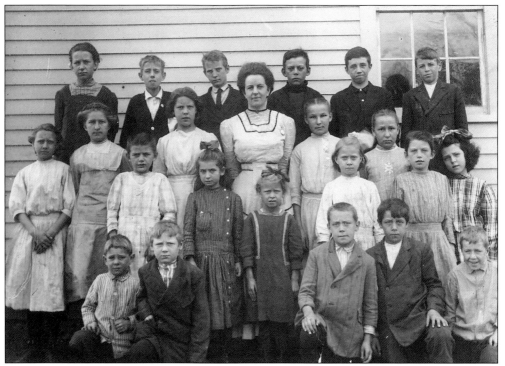

THE SOUTHWEST SCHOOL. Miss Ruth M. Tucker is shown here with her class, c. 1904.

66

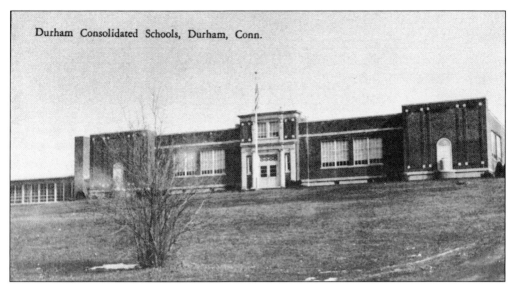

Durham Consolidated Schools, Durham, Conn.

THE DURHAM PUBLIC SCHOOL. This school, built in 1923, consolidated all six school districts. For the first time, all Durham students in grades one through twelve attended school in the same building. This school is now known as the Frank Ward Strong Middle School.

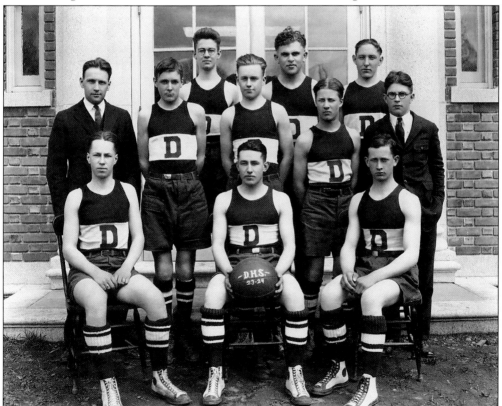

THE BASKETBALL TEAM OF 1923–24. Team members are, from left to right, as follows: (front row) W. Walkley, A. Arrigoni, and L. White; (middle row) Mr. Purdy, R. Page, M. Rich, C. Otte, and J. Jackson; (back row) F. Gastler, H. Zimmerman, and D. Johnson.

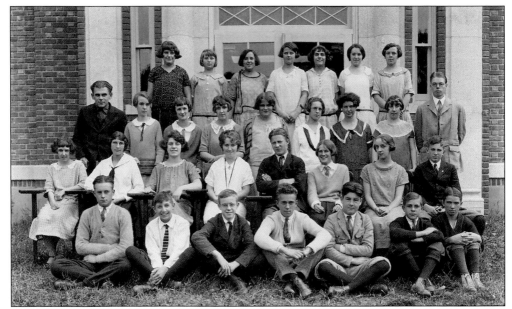

STUDENTS, 1924–28. Students are, from left to right, as follows: (front row) Morris Rich, W. Kupfer, F. Bode, R. Asman, C. Reilly, C. Gastler, G. Jackson; (second row) M. Rich, H. Brown, S. Groden, A. Barry, C. Otte, M. David, M. Banta, W. Parsons; (third row) H. Zimmerman, S. Francis, D. Alling, G. Powers, E. Filatore, L. Dannenberg, C. Burr, E. Bailey, unidentified teacher; (back row) E. Gordon, S. Charnysh, B. Hubbard, G. White, E. Zimmerman, M. Atwell, and D. Hall.

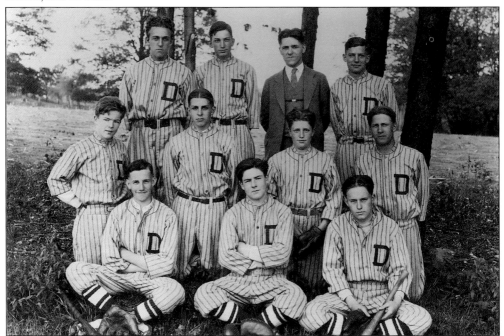

THE BASEBALL TEAM OF 1926. Players are, from left to right, as follows: (front row) J. Berten, C. Reilly, and M. Rich; (middle row) J. Reilly, C. Gastler, H. Thompson, and C. Otte; (back row) R. Asman, W. Parsons, Mr. Fitzgerald, and H. Moss.

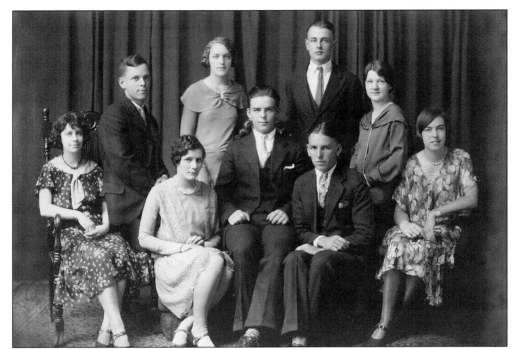

THE CLASS OF 1930. Pictured, from left to right, are Ceda Zeissett, Donald Moss, Ann Boublik, Helen Powers, Donald Rich, Arthur Wimler, Henry Coe, Marion Harvey, and Adele Francis.

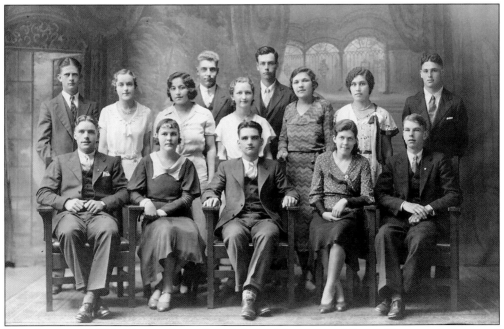

THE CLASS OF 1932. The students, from left to right, are as follows: (front row) Raymond Carter, Clara David, Walter Osborne, Daisey Gastler, and Gifford Francis; (middle row) Robert White, Ruth Powers, Rose Forline, Helen Chiszewsky, Beatrice Zimmerman, Mary Stromboli, and Azreal Soobitsky; (back row) Lawrence Goodale and James Pareis.

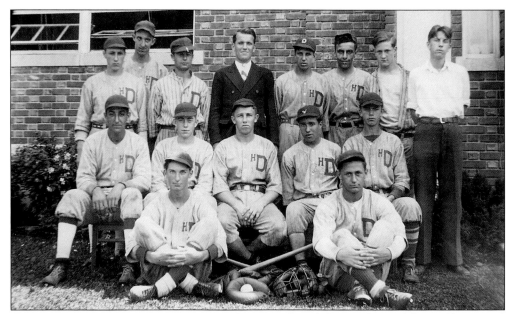

THE BASEBALL TEAM OF 1933. Team members are, from left to right, as follows: (front row) H. Brown and W. Thompson; (middle row) J. Scaglione, T. Davis, J. Suchanek, S. Pandiani, C. Charnysh, and F. Korn; (back row) R. Francis, R. Bentley, A. Aivano, Mr. Owens, A. Kupfer, G. Forline, and C. Stannard.

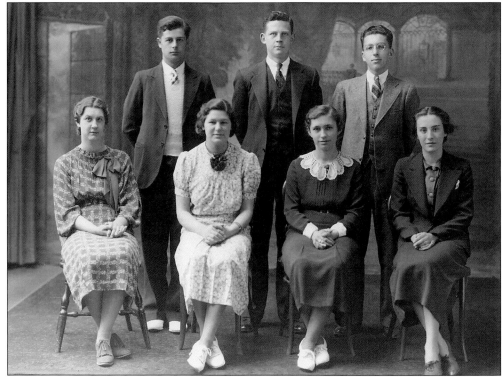

THE CLASS OF 1936. From left to right are as follows: (front row) E. Korn, A. Soobitsky, L. Vulk, and J. Guglielmetti; (back row) A. Aivano, F. White, and J. Otte Jr.

Five

ALONG THE ROAD

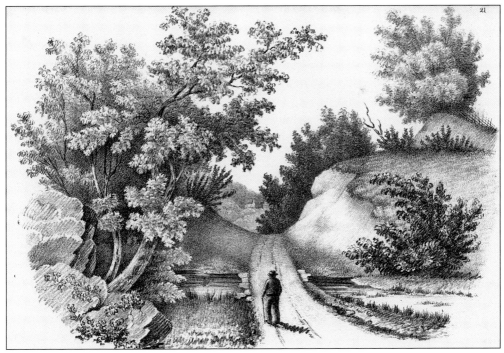

AN 1851 DRAWING BY BENJAMIN COE, A DURHAM ARTIST, DEPICTING AN EASTERN VIEW ALONG THE WALLINGFORD ROAD. The steeple of what is currently the United Churches can be seen in the distance.

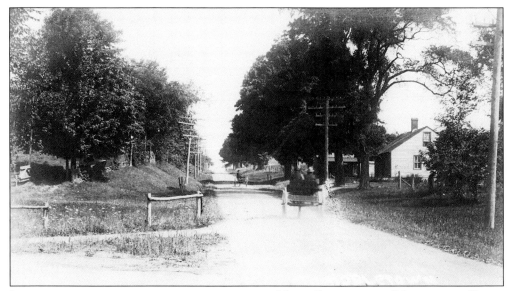

LOOKING NORTH FROM THE INTERSECTION OF MAIN STREET AND MIDDLEFIELD ROAD, c. 1905.

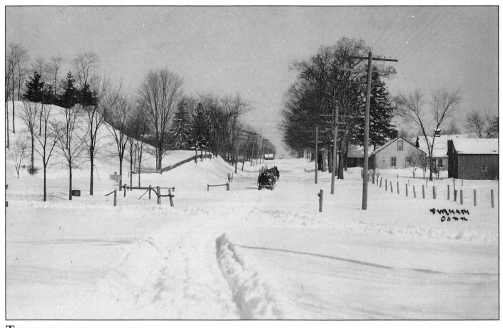

THE SAME SCENE IN WINTER.

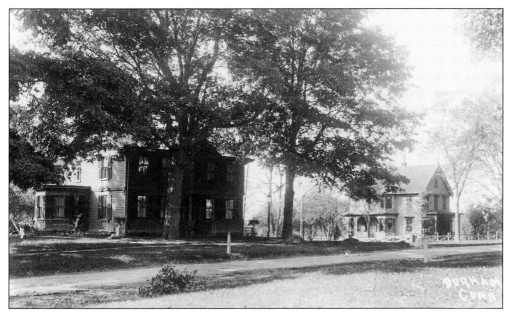

THE CORNER OF TALCOTT LANE AND MAIN STREET. The house on the right is now the location of C.M. Burr Realty; the house on the left belongs to Susan Abbe.

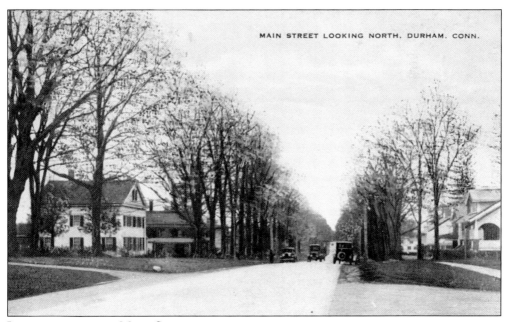

MAIN STREET LOOKING NORTH, DURHAM. CONN.

LOOKING SOUTH ON MAIN STREET FROM A VANTAGE POINT OPPOSITE THE INTERSECTION OF TALCOTT LANE. Note the incorrect title of the postcard.

THE FIRST HOUSE NORTH OF WHAT IS NOW NOTRE DAME CHURCH, CURRENTLY THE HOME OF LOIS SCHILLING. Note the hitching posts along the street.

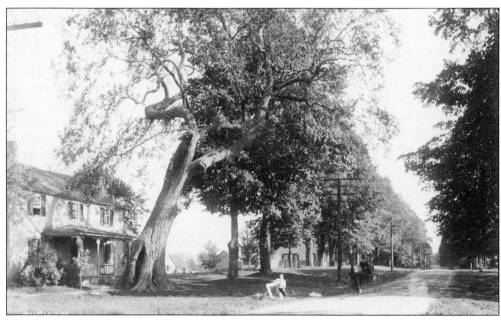

THE BAILEY HOUSE, c. 1905. This home sat where the Durham Pharmacy is today. The large elm tree in front was a local landmark.

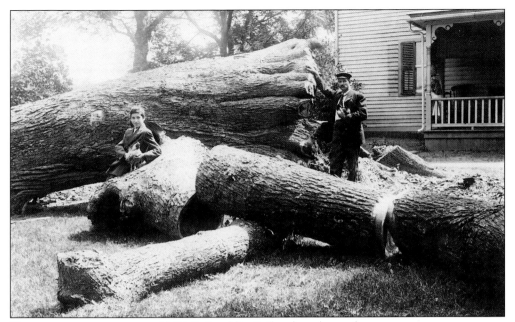

CUTTING DOWN THE ELM, c. 1905. J. Franklin Bailey does the work.

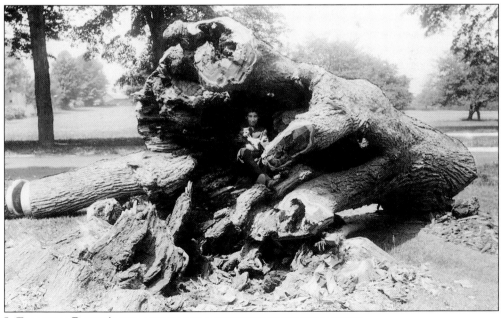

J. FRANKLIN BAILEY'S SON AND HIS DOG SITTING INSIDE THE ELM TREE.

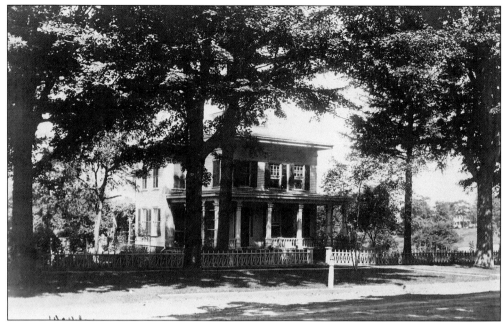

THE WALKLEY HOUSE, c. 1905. This house was later torn down. The Notre Dame rectory is now located on this site.

THE HOUSE, BUILT IN 1796, ON THE SITE WHERE THE UNITED CHURCHES STAND TODAY. The building was moved to its current location in 1847 to make way for the church. It is presently the home of Carl and Sheila Heck.

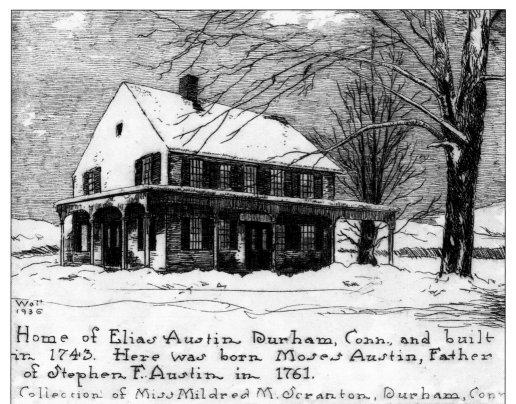

Home of Elias Austin Durham, Conn., and built in 1743. Here was born Moses Austin, Father of Stephen F. Austin in 1761.
Collection of Miss Mildred M. Scranton, Durham, Conn

THE AUSTIN HOUSE, HOME OF ELIAS AUSTIN, BUILT IN 1743. Moses Austin was born here in 1761. Moses Austin's son, Stephen F. Austin, went on to become the founder of Texas. This home is presently owned by Susan and William Gillespie.

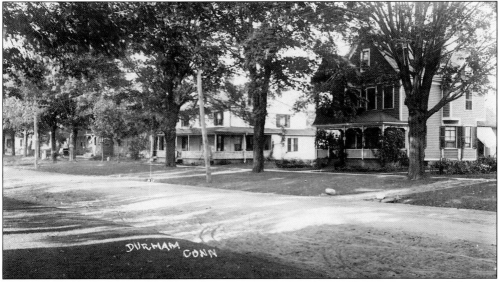

MAIN STREET LOOKING NORTHEAST AT THE TWO HOMES IMMEDIATELY SOUTH OF MERRIAM MANUFACTURING. The house on the left is owned by the Merriam Manufacturing Company; the house on the right by the estate of Helmut Gerber.

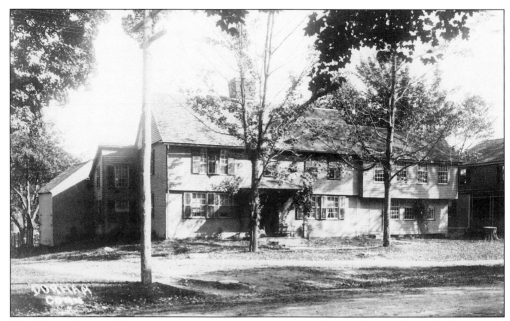

THE MOSES AUSTIN HOUSE ON THE SOUTHEAST CORNER OF MAIDEN LANE. Once the location of the Durham Post Office, the house's large wing on the south end was removed, and it is now the first house on the south side of Maiden Lane.

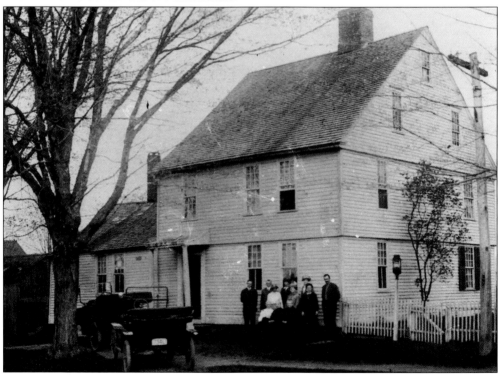

THE HOME OF STONECUTTER JOHN JOHNSON. Johnson had five daughters, none of whom ever married—hence the name of their street, Maiden Lane. It is said that one of the sisters did have a suitor, but a marriage never took place as the gentleman did not wish to break up the set.

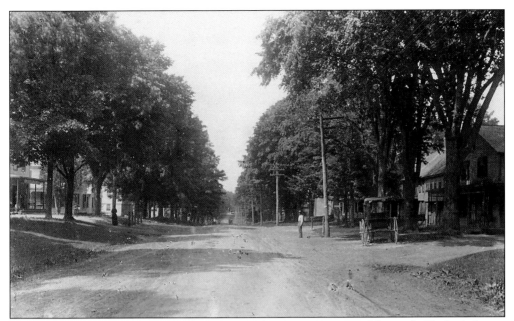

LOOKING NORTH AT ATWELL'S STORE, c. 1905 (NOW THE DURHAM MARKET). Tucker's Livery Stable is on the right.

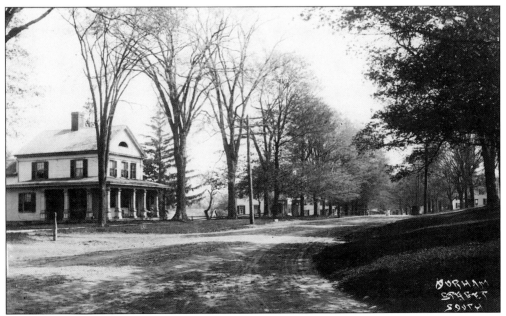

THE COE HOME, NEAR THE JUNCTION OF WALLINGFORD ROAD AND MAIN STREET, c. 1905. This house is now owned by Richard and Daniel Kellish.

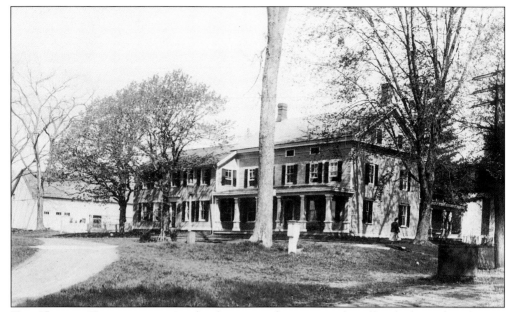

THE HARVEY HOUSE, c. 1905. This house, at the corner of Wallingford Road and Main Street, was acquired by the United Churches in the 1950s. The porch, addition, and barn were removed to make way for a fellowship hall, and the house was returned to its original gambrel-roof construction. Notice the watering trough to the right and the white signpost, one of many throughout town used for the posting of notices.

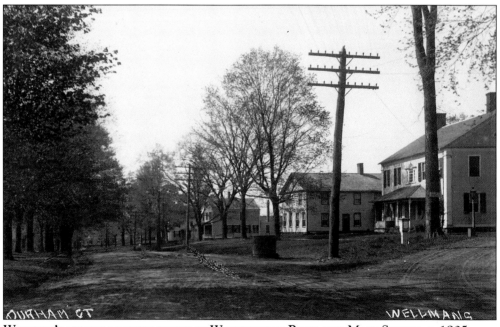

WELLMAN'S CORNER LOOKING SOUTH OF WALLINGFORD ROAD AND MAIN STREET, c. 1905.

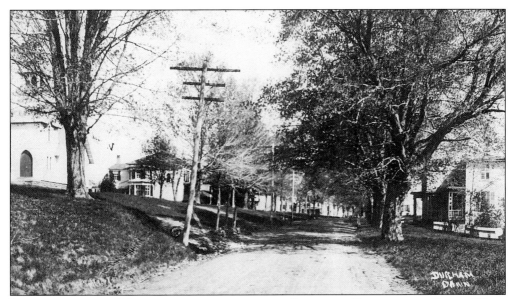

LOOKING NORTH ON MAIN AT A POINT BETWEEN THE CHURCH OF EPIPHANY AND FRANK WARD STRONG SCHOOL, c. 1905.

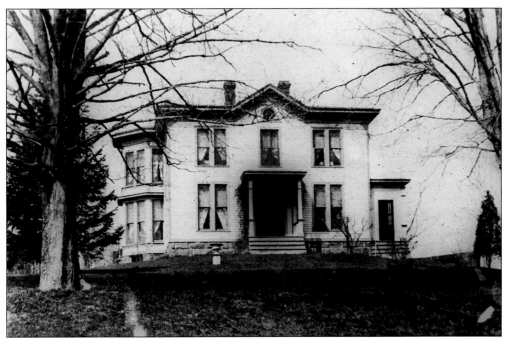

THE HOME OF DR. MARKHAM, c. 1905. This house is on Main Street opposite Strong School.

MILL BRIDGE ACROSS ALLYN'S BROOK. This stone bridge was built in 1823 at a cost of $852.37. It replaced the original wooden bridge, which was washed out in a flood the year before. This bridge collapsed as a stagecoach was crossing it, and two people died as result of their fall into the icy brook. This stone bridge is still in place today beneath the modern bridge.

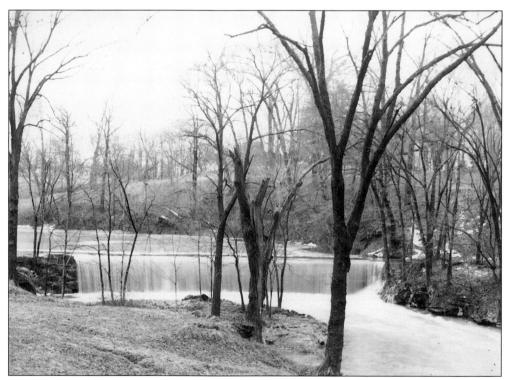

MILL POND ON MAIN STREET. This was the site of one of the first businesses in town, a grist mill built in 1709. The mill remained in use until 1869 when it was destroyed by a flood.

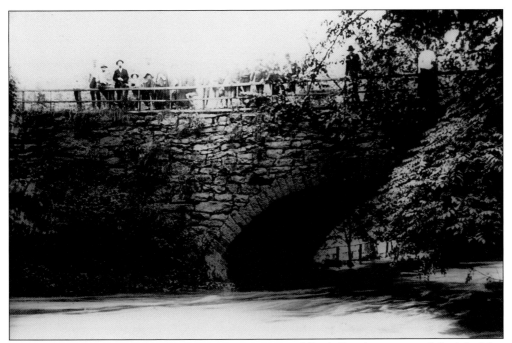

VIEW OF MILL POND FROM ALLYN'S BROOK, c. 1920. Allyn's Brook was named for Mr. John Allyn, who, in 1672, purchased land from Tarramuggus, sachem (chief) of the Mettabesset tribe.

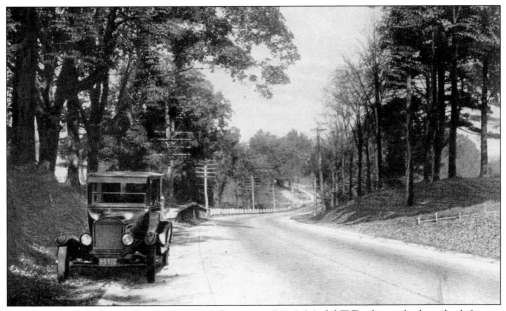

LOOKING TOWARD MILL BRIDGE, c. 1925. Benjamin Page's Model T Ford is parked on the left.

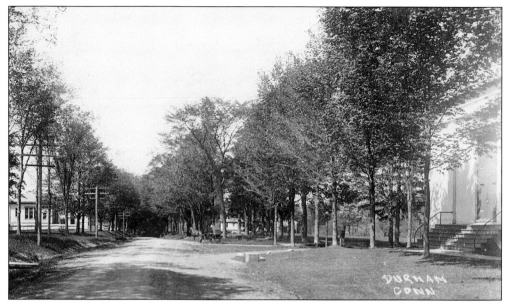

LOOKING NORTH WITH THE METHODIST EPISCOPAL CHURCH ON THE RIGHT AND THE LIBRARY ON THE LEFT, c. 1905.

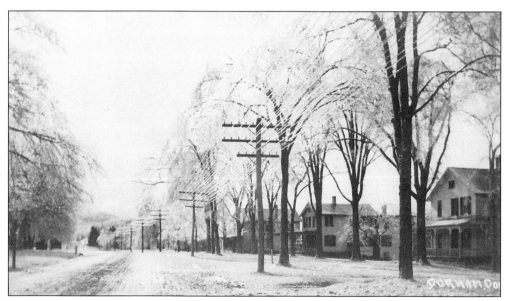

THE FIRST HOUSE SOUTHWEST OF THE TOWN GREEN, c. 1905.

THE FIELD HOME ON FOWLER AVENUE, DIRECTLY EAST OF THE CURRENT POST OFFICE, c. 1905.

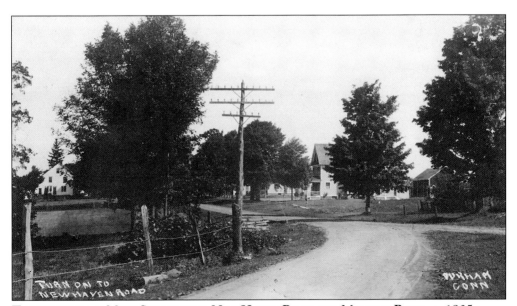

THE JUNCTION OF MAIN STREET WITH NEW HAVEN ROAD AND MADISON ROAD, c. 1905.

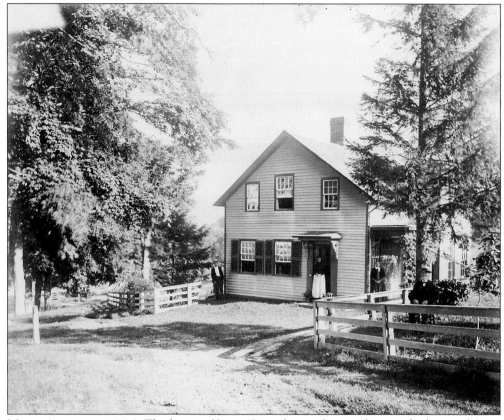

MAPLE AVENUE, c. 1895. The home of James Parmelee, a silversmith, now the home of Gene Brown and family.

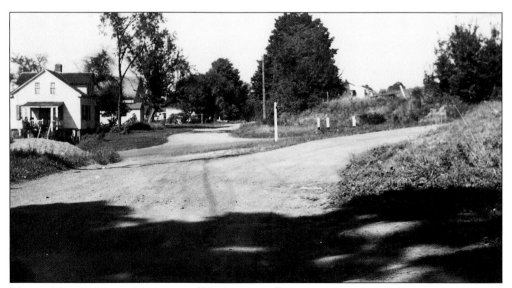

MAPLE AVENUE LOOKING NORTH AT WALLINGFORD ROAD.

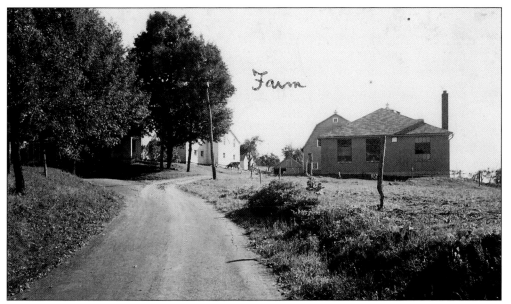

SOUTH ALONG CHERRY LANE, STANNARD'S VALLEY VIEW FARM ON THE RIGHT, C. 1930S.

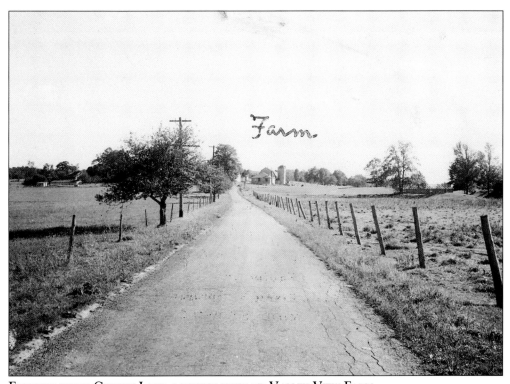

FARTHER DOWN CHERRY LANE, LOOKING TOWARD VALLEY VIEW FARM.

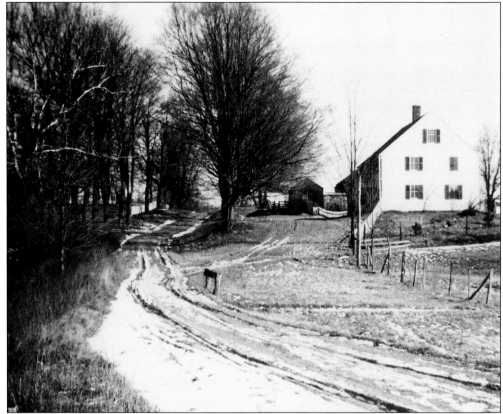

A.S. Newton's home, looking east along Haddam Quarter Road, c. 1915. This is now the home of the Tempels.

North along Maiden Lane, c. 1915. J.E. Newton's barn is on the right.

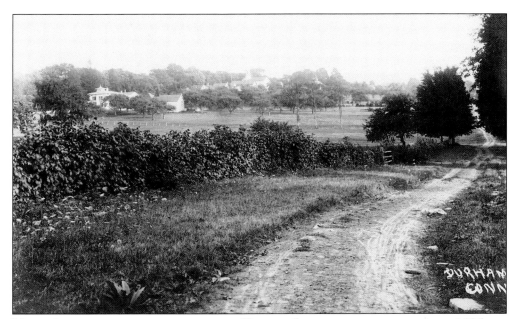

MAPLE AVENUE NEAR THE INTERSECTION OF TALCOTT LANE, LOOKING SOUTHEAST, c. 1905.

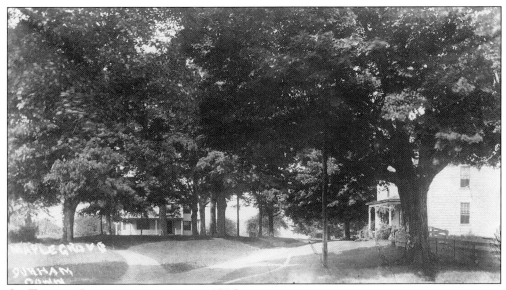

ON TALCOTT LANE, LOOKING WEST, c. 1905.

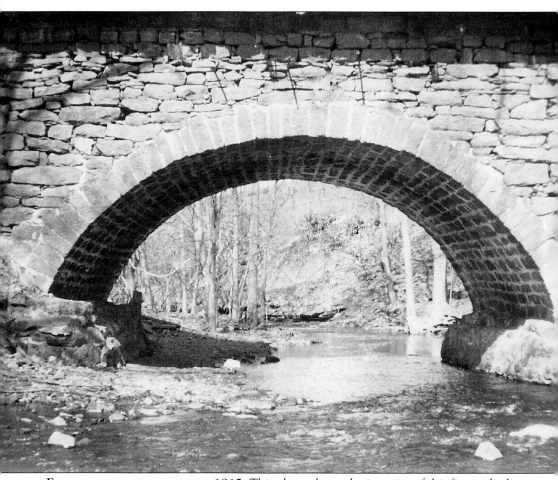

EARLY VIEW OF STONE BRIDGE, c.1915. This photo shows the integrity of this fine arched stone bridge over Allyn's Brook at Main Street. It can still be seen under the present road via a pedestrian walkway.

Six

GOVERNMENT

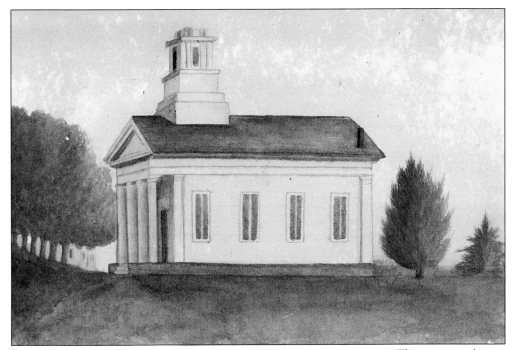

AN 1876 PAINTING BY MARY E. HART (1836-1899), A DURHAM ARTIST. This painting depicts the South Congregational Church, which became the Durham Town Hall in 1886.

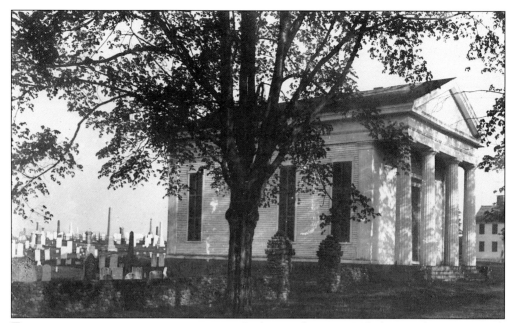

THE TOWN HALL CHANGING WITH THE TIMES. In the top photo, c. 1905, the steeple was removed, but the town hall retained its classic Greek Revival columns. In the lower photo, taken sometime in the 1930s, a fire escape has been added and the columns replaced by a porch and second-story veranda

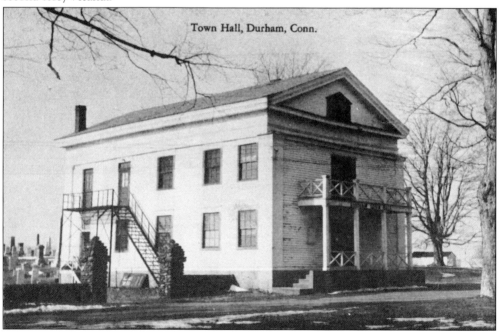

Town Hall, Durham, Conn.

THE SELECTMEN

OF THE

TOWN of DURHAM.

HEREWITH SUBMIT THEIR REPORT OF THE

Expenses of the Town,

For the Year Ending Sept, 30th. 1871.

————◆●◆————

For Working Highways and Repairing Bridges,	$ 890.63
" Town appropriation for Schools,	1,426.00
" Interest on Ebenezer Robinson donation paid Center District,	64.49
" Services of School Visitors,	48.00
" Indebtedness and interest paid,	861.50
" Attorneys Fees and Expense of Witnesses in the Thompson case,	201.00
" Support of Town poor—including $234.87 for expense of Jane E. Thompson prior to October 1, 1870, and $161.19 refunded by the State and other towns,	1.131.74

As follows:

Expense of Dinah Freeman,		$109.06
"	" Johansen,	98.34
"	" Martin Lyden,	144.41
"	" Mrs. Clark,	159.92
"	" Betsey Crandall,	5.50
"	" Jane E. Thompson,	387.06
"	" Harriet Hall,	78.00
"	" Bart. Lyden,	28.34
"	" Maria Lyman,	2.50
"	" keeping Travelers,	16.69
"	" Albert Wheeler,	9.25
"	" Whitmore Family,	56.85
"	" Eliza Johnson,	15.00
"	" George Thomas,	12.87
"	" investigating other cases,	7.95
		$1.131.74

For State tax paid,	$997.10
" County tax paid,	18.00
" Military tax paid,	126.00
" damages done sheep,	18.50
" abatements to Collector,	16.96
" Services of Town Officers and ordinary expenses,	222.44
	$6.022.36

Orders on the Treasurer from No. 1 to 117 inclusive for the above amount,	6.022.36

THE *Town Report*, 1871.

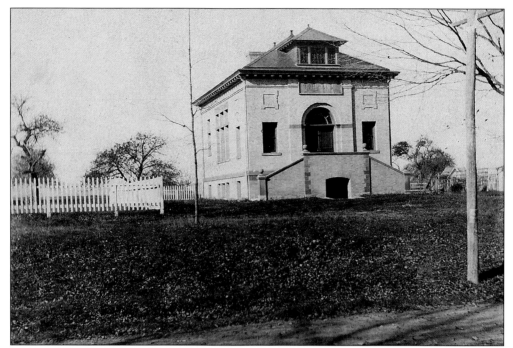

THE DURHAM PUBLIC LIBRARY, c. 1905. The original Durham library was organized on October 30, 1733, as the Durham Book Company and continued operation until it was disbanded in 1856. In 1894, the present library was established by a town vote. Land for the new building was donated by Mrs. Charles G. Rockwood, and the cornerstone was laid in 1901. Some of the money raised to erect the building came from local school children who donated ten cents each to the building fund. The library was dedicated in 1902.

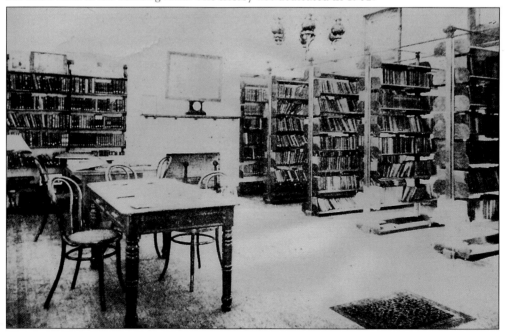

LIBRARY INTERIOR, c. 1905.

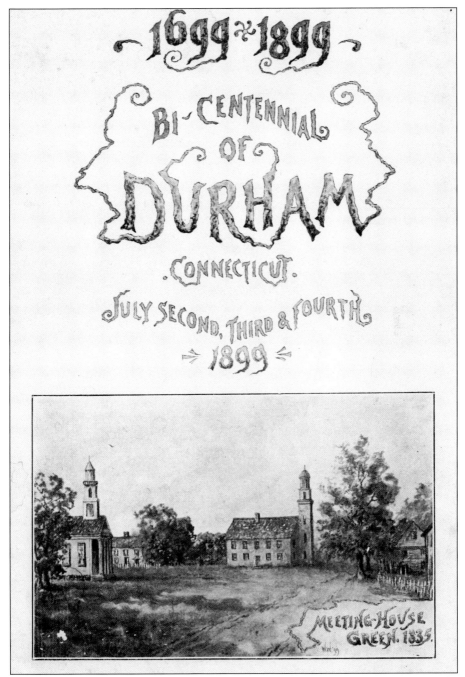

DURHAM BICENTENNIAL PROGRAM COVER, 1899. Well-known Durham artist Wedworth Wadsworth created this program cover to celebrate the 200th anniversary of the settlement of Durham. Wadsworth copied the scene, the earliest known view of the Meeting House Green, from an earlier work originally executed and printed in the *Connecticut Historical Collections* (1836) by John W. Barber. The church just to right of center is the second Congregational church, which was dismantled in 1835. It was replaced by the church on the left.

Value Assessed *1500*　　　　　Durham, Conn., *Apr. 1*　　　　　190 *9*

M *Mrs. E. A. Twitchell*

To TOWN OF DURHAM, *Dr.*

B. F. PAGE, Collector.

To Town Tax on Levy of Oct. 1, 1908, 12 Mills on a Dollar, due March
23, 1909, without rebate, - - - - - - - - - $ *18.00*

To Poll or Military Tax, - - - - - - - -

Lien, - - - - - - - - - - - -

Recording Lien, - - - - - - - - - -

Interest from March 23, 190_____, to _____

$ *18.00*

Received Payment, *B. F. Page by M. Page* (Collector.)

Interest after March 23, 1909, at 9% must be collected as per Section 2391-2393 of the Revised Statute.

A TAX RECEIPT FROM 1907. These taxes were received from Mrs. E.A. Twitchell by Benjamin
Page. The mill rate (here 12) was set annually according to town needs. Property owners paid
$1 per $1,000 of property value. Today the mill rate is 27.25.

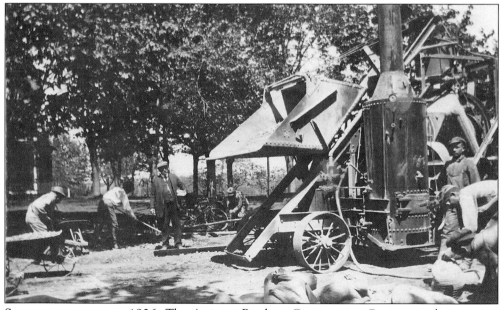

SIGNS OF PROGRESS, c. 1926. The Arrigoni Brothers Construction Company is busy paving
Main Street.

Seven

WAR AND DISASTERS

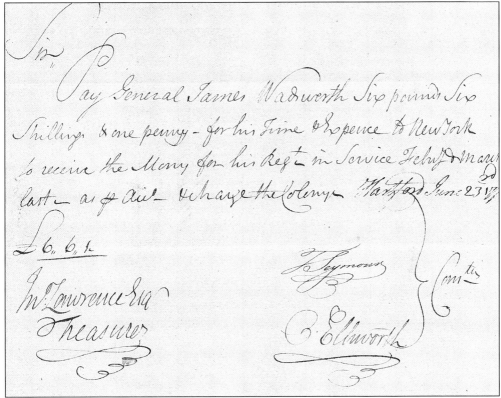

RECEIPT FOR SERVICES, 1776. Gen. James Wadsworth was a prominent Durham resident. Born on July 6, 1730, he received a bachelor of arts degree from Yale in 1748 and went on to study law. In 1756, Wadsworth became town clerk, an office he was to hold until 1786. In 1775, he was appointed a colonel in the militia, within a year he was promoted to brigadier general of the Connecticut Militia, and the following year he was again promoted, this time to 2nd major general. In addition to his military duties, Wadsworth also served as a member of the council of safety and even served one term in the Continental Congress. After independence, Wadsworth's public service did not end; from 1785 until 1789, he was the controller of the State of Connecticut as well as a member of the governor's council. Maj. Gen. James Wadsworth died in 1817 at the age of 87.

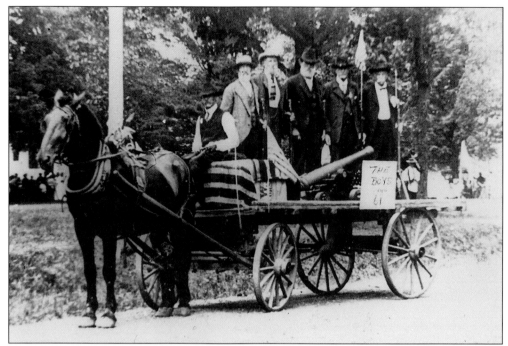

THE BOYS OF '61, PHOTOGRAPHED IN 1905. Six survivors of the Civil War hold a position of honor at the Fourth of July parade. Durham men fought in most of the major battles of the Civil War. Approximately 100 served, and 12 never returned. On August 31, 1865, a large celebration was held for the returning troops. A procession began at the town green, marched to the residence of the Honorable James Wadsworth, orator of the day, and then marched past the green to Lyman's Grove. The procession included a "car of beauty," containing 36 young ladies robed in white, each wearing a red, white, and blue sash to represent the 36 states; the cornet band; drum corps; and veterans of the War of 1812. After the oration, dinner was served; a table more than 650-feet long was needed to serve all those in attendance.

Hartford, *September 6th* 1780.

RECEIVED, of Pay-Table-Committee, their Order

on the Treasurer, of this State, to secure the Payment

of *Forty four pounds five shillings & eleven pence L.M*
Hugh Hinman
being the Balance due to ~~me~~, on the first Day of January

last, as stated by the Committees of the State and of the

Army. — *For Hugh Hinman*

£ 44 – 5 – 11 *Abel Tibbals*

RECEIPT FOR SERVICES, 1780. Hughston Hinman received 44 pounds, 55 shillings, and 11 pence for his service in the 6th Connecticut Battalion of the Continental Army.

DURHAM
WAR RALLY

At the Methodist Episcopal Church, Durham

SUNDAY EVENING, DEC. 9, 7:30 o'clock

Miss Grace N. Murray of Guilford

and Mr. Herbert Knox Smith of Hartford

Will Speak under the auspices of the Connecticut Council of Defence

This War Rally has been arranged by the local town Committee of the Connecticut State Council of Defence and it is the duty of every citizen to attend. Come and hear the message which will be brought by the well known speakers. An inspiring meeting is assured.

Come and learn how the Kaiser's Program of Conquest has been carried forward thus far on years-old schedule; Why Germany wants peace now; The meaning of the latest European Developments; What Prussian victory would mean to America; What the United States has done since war was declared; What YOU can do to help America win the war and bring enduring peace to the world.

It is owing to the limited seating capacity of the Town Hall that the Committee decided to have this Rally in the Methodist Church. The meeting will be non-sectarian and no collection will be taken.

PLEASE BE PRESENT

J. D. Young Printer, Middletown

WAR RALLY, 1918. A leaflet calls Durham residents to a meeting at the Methodist church to hear "what you can do to help America win the war . . ."

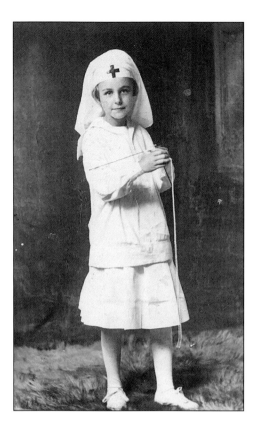

Sylvia Francis, 1918. The inscription on the back reads, "I'm a little Red Cross nurse/And I can do my bit/By saving bottles and tin foil/And learning how to knit."

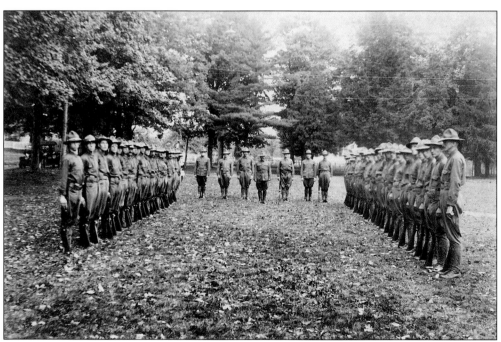

The Home Guard drilling on the town green in 1918. Twenty Durham men fought in World War I. Luckily, all returned home safely.

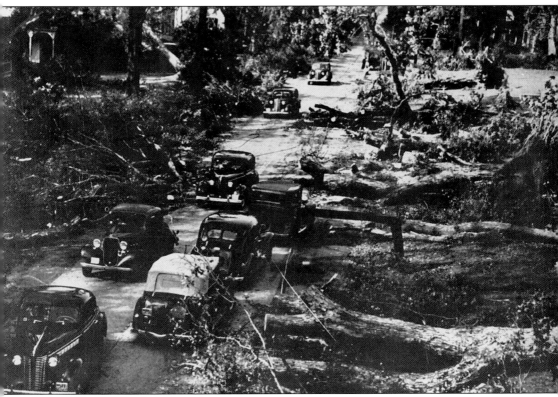

THE HURRICANE OF 1938. In general, Durham has been very fortunate in escaping natural disasters. However, the hurricane which hit the eastern seaboard in 1938 left its mark on the town. The newspaper caption read, " . . . every tree on the east side of the highway (Main Street) went down like a row of dominoes." (Photographed by Raymond C. Lewis.)

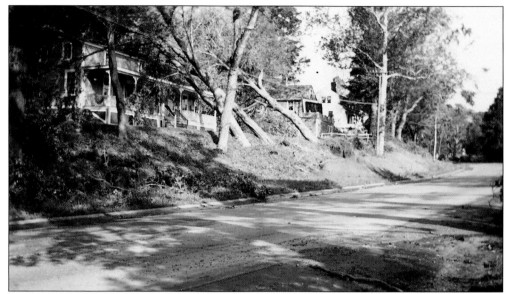

THE GOODALE HOME ON MAIN STREET.

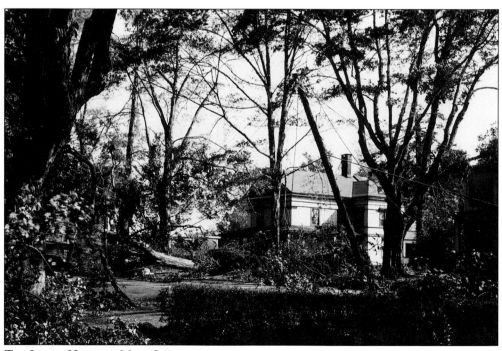

THE LEACH HOME ON MAIN STREET.

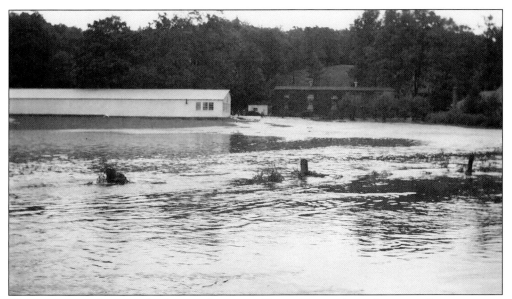

HIGH WATER AT ARRIGONI'S GARAGE (NOW THE TOWN GARAGE) ON GUILFORD ROAD.

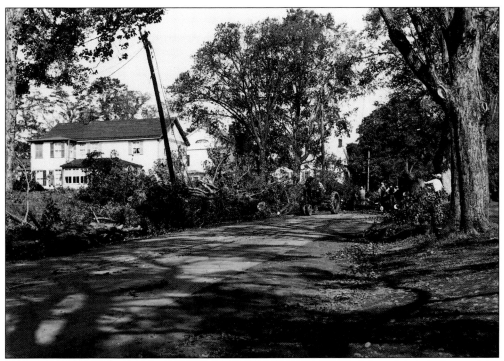

MAIN STREET LOOKING NORTH. Billy Stannard, on the tractor, helps clear debris in front of the Brainard House.

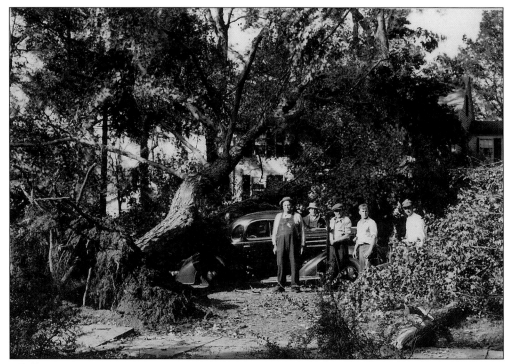

J.F. Bailey and the state road crew removing a tree from a car.

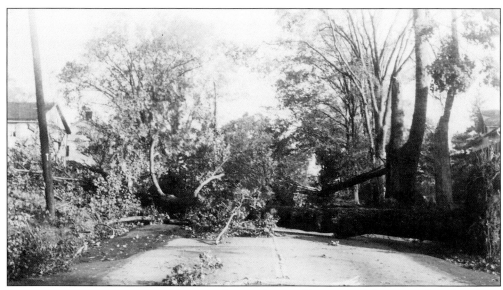

Looking on the bright side. Many roads were impossible to travel for many days, but there was a wonderful supply of firewood, some say for years.

Eight

FARMING AND THE FAIR

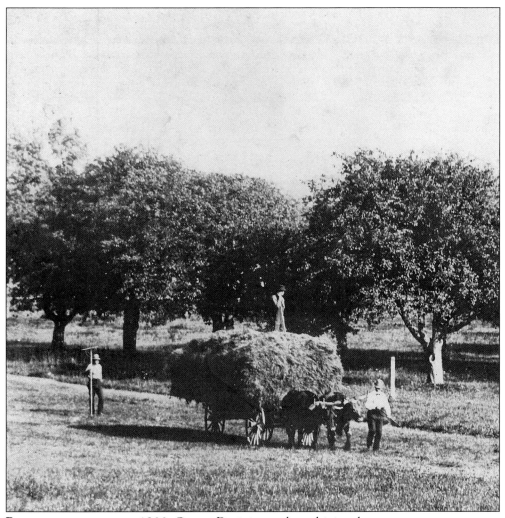

BRINGING IN THE HAY, c. 1900. George Davis is seen here driving the oxen.

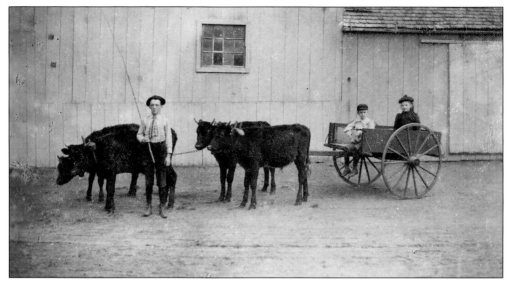

TRAINING A NEW TEAM, c. 1900. Charles Watson Newton, switch in hand, poses with a double team. A new pair of oxen learned their job by being worked with a more experienced ox. Roger Rossiter and Katharine H. Newton ride in the wagon. A few years later, Newton was to lose his life in a wagon accident.

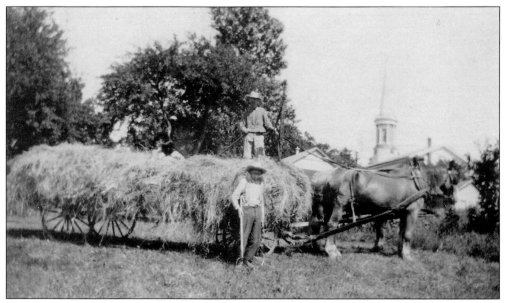

TAKING A BREAK. A hard-working team of horses and men pause for a moment during haying on the Harvey Farm on Wallingford Road. In the background, the steeple of the United Churches of Durham can be seen.

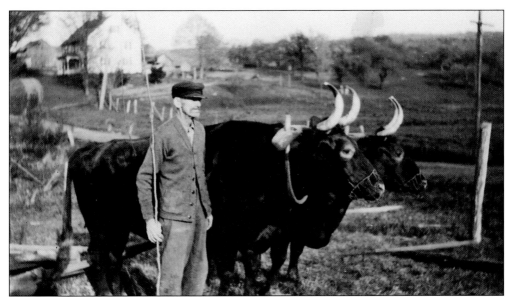

J.E. NEWTON WITH HIS OXEN, 1932. Oxen were a common sight in Durham well into the 20th century. Oxen were easy and inexpensive to care for, and their strength and steady disposition could be relied on for all manner of farm work. Notice the baskets on the muzzles of this pair; oxen were easily tempted to taste the crops they were used to harvest. In the photo below, the same team brings in the hay on the Newton family homestead located on Haddam Quarter Road.

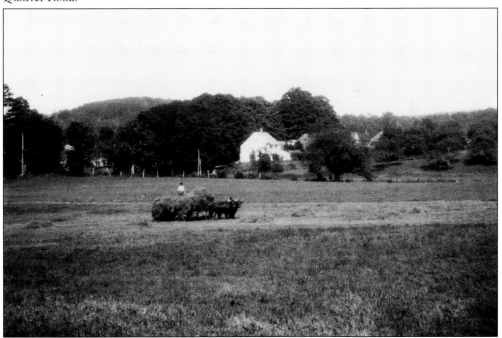

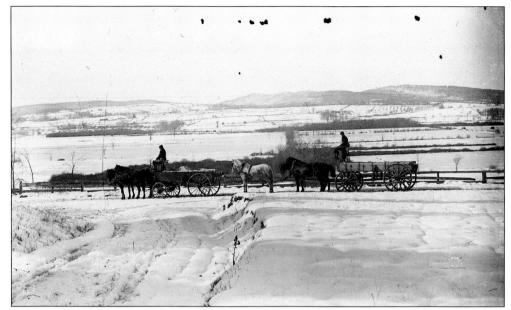

A HORSES AND WAGONS. Long after the automobile became a common sight on Main Street, horse-drawn wagons continued to play an important role in farm life. This winter scene shows some hardy teams bringing supplies through roads that would probably not have been passable to automobiles of the day.

BROOKFIELD FARM, LOCATED ON THE WALLINGFORD ROAD AND OWNED BY FREDERICK BREWSTER, A WEALTHY FINANCIER.

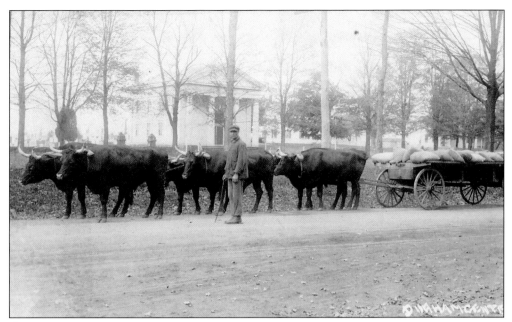

A WAGONLOAD HEADED SOUTH IN FRONT OF THE TOWN GREEN.

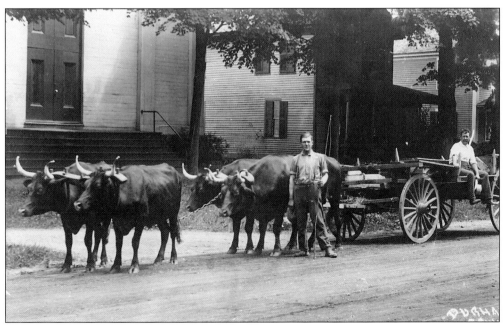

JOSEPH PETROSKY AND HENRY I. PAGE WITH A WAGON AND TWO TEAMS OF OXEN IN FRONT OF THE METHODIST EPISCOPAL CHURCH, NOW THE DURHAM GRANGE.

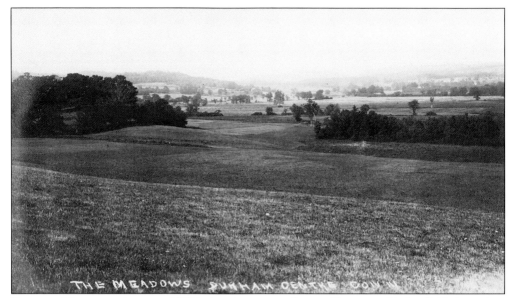

DURHAM MEADOWS, AUGUST 1907. As trim as a modern golf course, this hayfield shows just how efficient a good team could be. Hay played an important role in Durham farm life; in addition to its use as animal feed, hay could be a source of income for a farmer as it was used as packing material by the metal box factories in town.

THE MAGNANO'S DUCK FARM ON HADDAM QUARTER ROAD. Henry Berten's farm can be seen in the background.

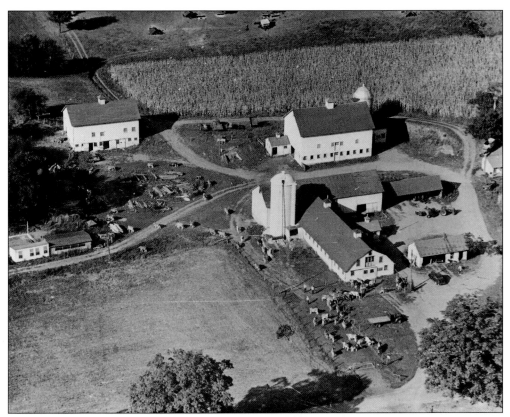

THE COE FARM, 1930s. This large modern farm was located on Stagecoach Road.

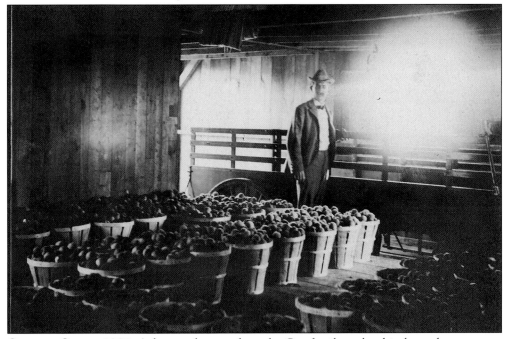

CLIFFORD COE, c. 1920. A fragrant harvest from the Coe family orchard is shown here.

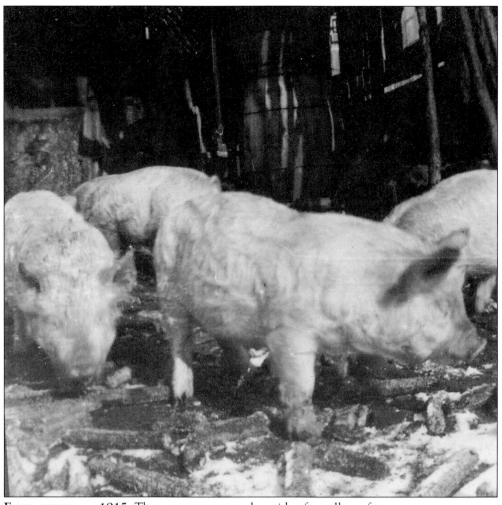

FARM ANIMALS, c. 1915. These creatures were the pride of a well-run farm.

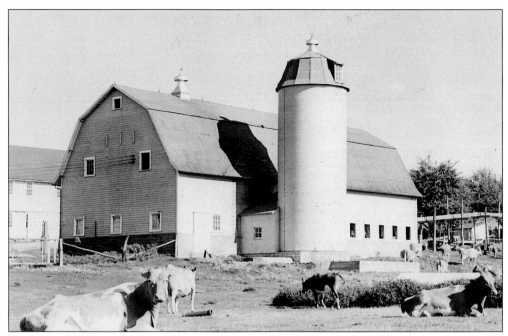

THE VALLEY VIEW FARM ON CHERRY LANE, 1920S. Cows and chickens provided quality products to bring to market for the Stannard family.

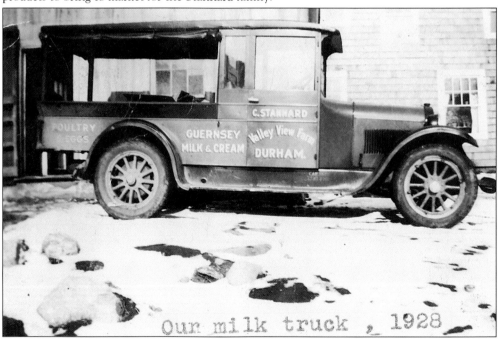

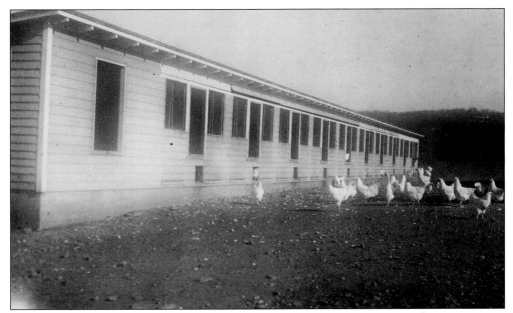

VALLEY VIEW FARM'S POULTRY HOUSE.

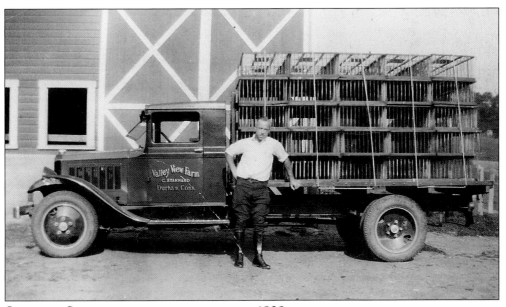

CLEVELAND STANNARD AND HIS POULTRY TRUCK, 1930.

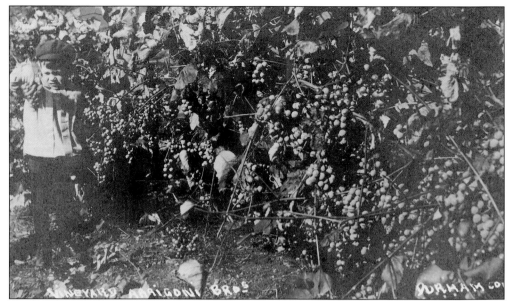

ARRIGONI BROTHERS VINEYARD, 1905. This industrious family ran a vineyard, made and sold charcoal, and had the largest construction company in the state.

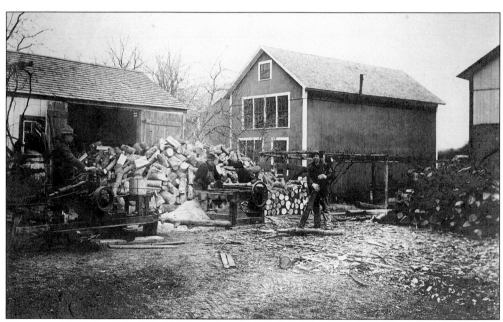

WOODCUTTING, C. 1910. The advent of power equipment dramatically changed farm life. A necessary, if laborious, chore like woodcutting was made faster and easier by the use of a power saw. (Photographed by John F. Main.)

THE DURHAM FAIR.
Over the last century, Durham has become known throughout New England for the agricultural fair it holds every autumn. The fair was founded by the Durham Grange to provide local farmers with the opportunity to show off their livestock, socialize with their neighbors, and see, first hand, exhibitions of new developments in agriculture. The first fair was held on Wednesday, October 4, 1916, and began with a grand parade down Main Street. The entire fair was held on the town green; local Boy Scouts camped out the night before to ensure no mischief was done to the exhibits. General admission was 25¢; a membership ticket, which entitled one to exhibit at the fair, cost 50¢. In addition to the judging of livestock and produce, the first fair featured events for cooking, needlework, and "domestic science." There were also sporting events held for men and boys and decorated parade float contests. Looking at the photos on the following pages, you can almost imagine standing by the side of the road as the excitement and anticipation build.

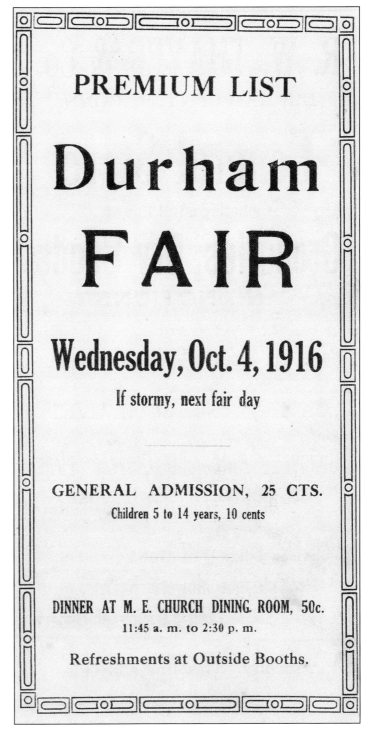

PREMIUM LIST

Durham FAIR

Wednesday, Oct. 4, 1916

If stormy, next fair day

GENERAL ADMISSION, 25 CTS.

Children 5 to 14 years, 10 cents

DINNER AT M. E. CHURCH DINING. ROOM, 50c.

11:45 a. m. to 2:30 p. m.

Refreshments at Outside Booths.

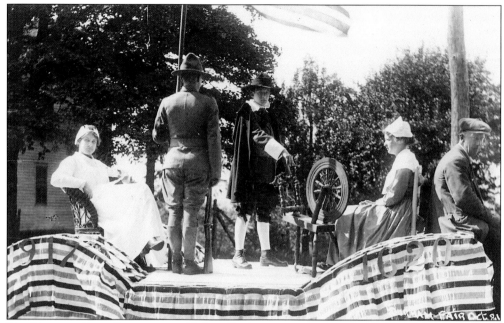

THE DURHAM FAIR. Every aspect of life in Durham was on display in the grand parade opening the fair. There was something to suit everyone's interest in the resulting pageantry.

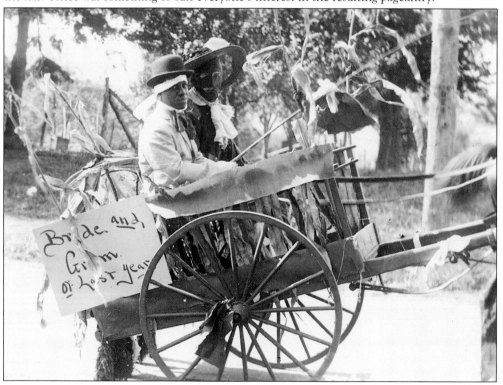

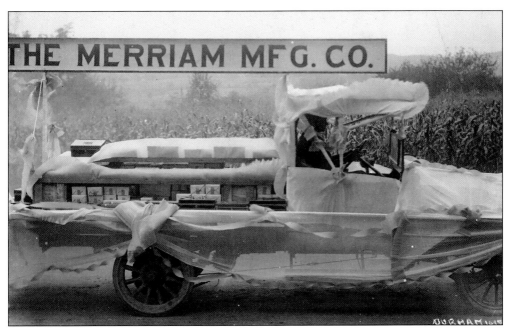

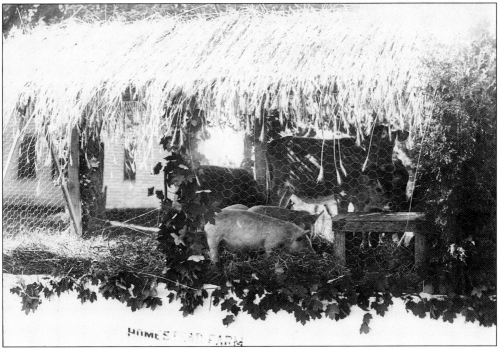

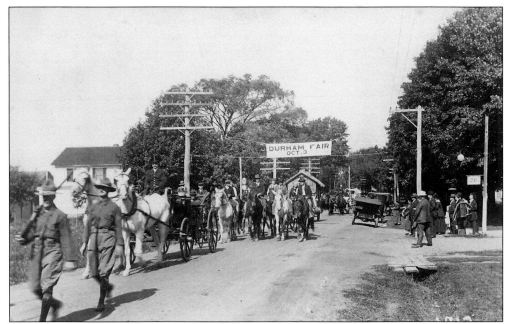

THE DURHAM FAIR. From a good vantage point, you could see it all.

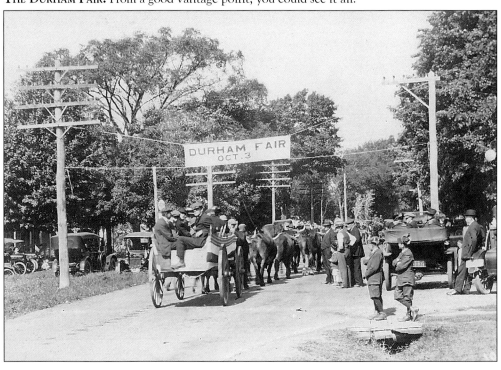

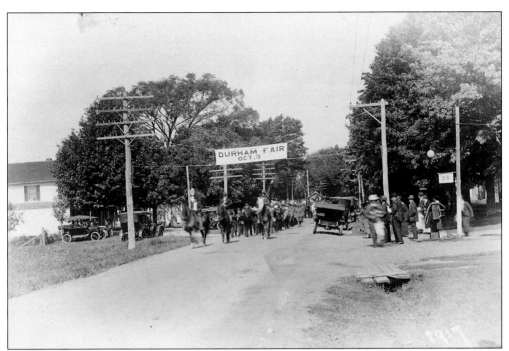

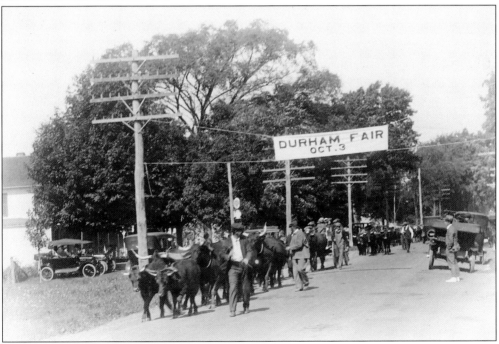

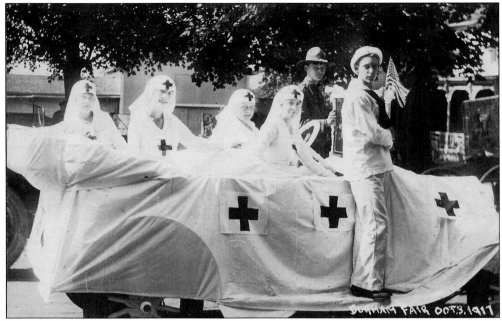

THE DURHAM FAIR. Everyone in town wanted to be a part of the show.

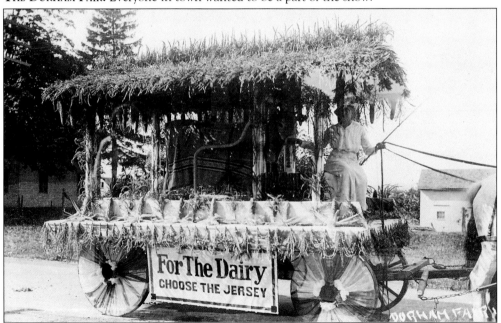

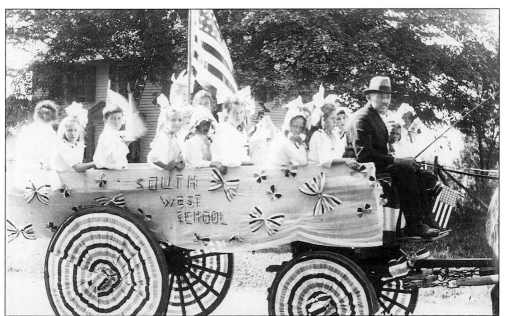

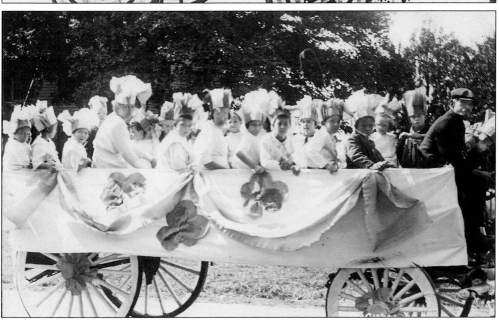

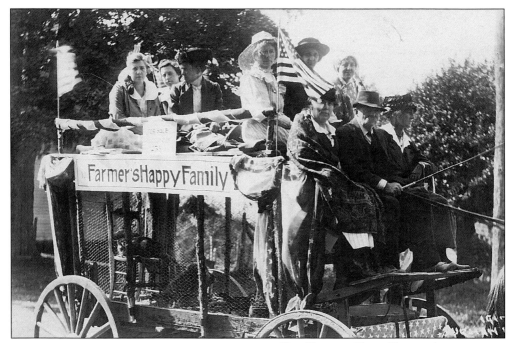

THE DURHAM FAIR. Tremendous preparation went into this agricultural celebration.

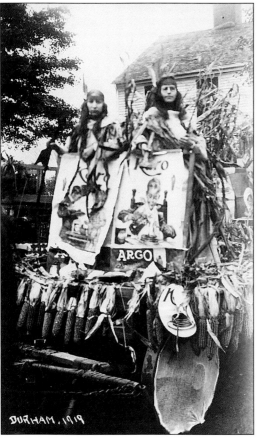

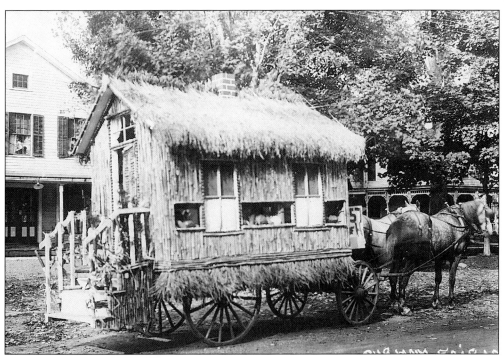

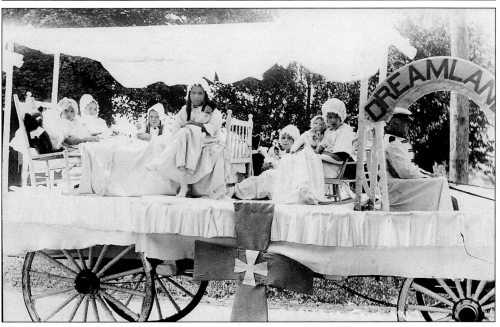

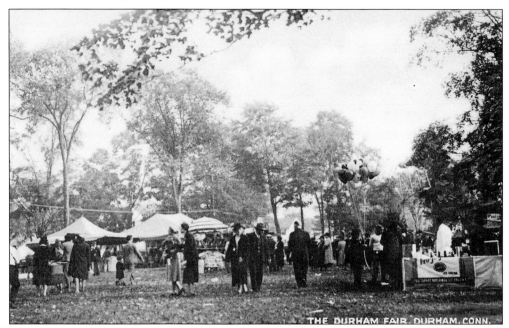

THE DURHAM FAIR. DURHAM. CONN.

Destination point—the town green and the now familiar bustle of the Durham Fair. For one day, the green was transformed into a place of excitement. Horses and cattle were tied to the giant elm trees, and food booths and exhibits lined the walkways. In addition to the agricultural contests, entertainment included pulling contests, sporting events, and, for the more daring, the giant Ferris wheel.

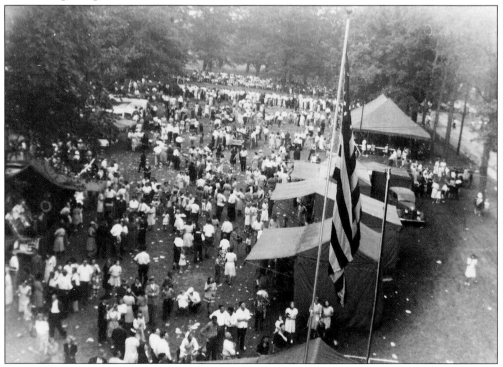

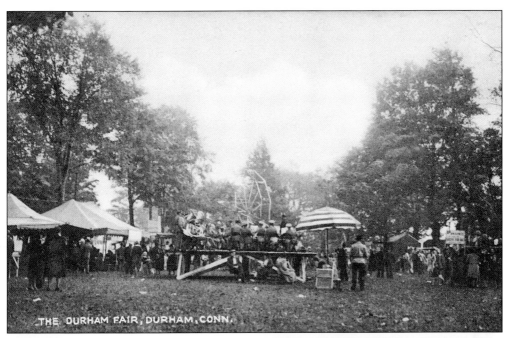

THE DURHAM FAIR, DURHAM, CONN.

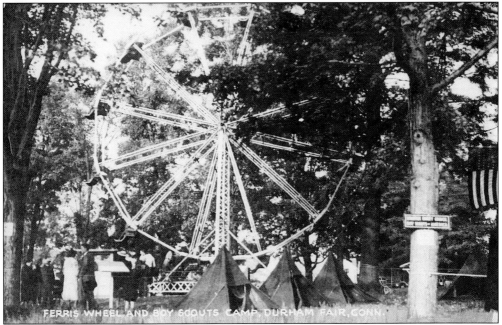

FERRIS WHEEL AND BOY SCOUTS CAMP, DURHAM FAIR, CONN.

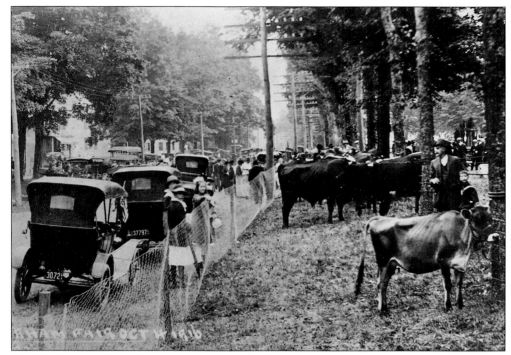

THE DURHAM FAIR ON THE GREEN, 1916. Cattle, oxen, and horses graze while anxious spectators arrive for a day at the fair.

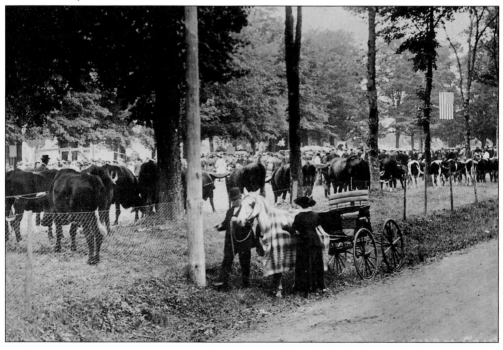